D0190336

SNOWDON SITTINGS

SNOWDON

SITTINGS
1979-1983

INTRODUCTION BY JOHN MORTIMER

WEIDENFELD & NICOLSON · LONDON

Photographs and text copyright © Snowdon 1983
Introduction copyright © John Mortimer 1983

All rights reserved
No part of this publication may be reproduced,
stored in a retrieval system,
or transmitted in any form or by any means, electronic,
mechanical or otherwise,
without the prior permission in writing of the copyright owners.

Designer: Barney Wan
Editorial Director: Mark Boxer
George Weidenfeld and Nicolson Limited,
91 Clapham High Street, London SW4 7TA
Produced in co-operation with Condé Nast Publications

ISBN 0 297 78314 9

Colour separations by Newsele Litho Ltd.
Filmset by Keyspools Ltd, Golborne, Lancashire
Printed and bound in Italy by L.E.G.O. Vicenza

For Lucy, David, Sarah and Frances

INTRODUCTION

JOHN MORTIMER

It is a popular belief among certain tribes that the camera drains away the soul. Many African natives cover their faces and turn away in horror at the sight of a photographer. There may be some truth in this belief, as those who are most frequently photographed, film stars, models and politicians, often look as though their souls have been drawn out by the all pervading lens.

The camera can also be used as a protection against any fierce or unusual sight. How painful the lot of tourists would be if they actually had to see Delphi, or Chartres Cathedral, or the Grand Canyon. The cameras they carry are for protection, a click of the shutter and such awesome spectacles can be reduced to a collection of little coloured slides, pretty as postcards, which can be taken home and forgotten.

For the camera, in the wrong hands, can give an air of spurious elegance to the world. The meanest tenements, the most appalling slums, photographed in grainy black and white, have been made into chic backgrounds for fashion models showing off the Spring Collections in the glossy magazines. Not only can the camera lie, it is extremely hard to persuade it to tell the truth.

Apart from the clear deception of presenting Miss Pamela Stephenson disguised as various film stars, the pictures in this book are all in quest of a certain truth about their sitters. It is not truth caught in a moment, like an assassination or a car crash. It's not a split second exposure while the camera's motor whirrs and the wind machine lifts the hair, the cheeks are sucked in, the lead singer howls on the tape and the photographer chants, 'Great! Great!' at a dazzling succession of empty gestures. It's a truth sought in a long sitting, on a wooden chair in a small daylit studio, accompanied by a good deal of silence; a slow process in which both the sitter and the photographer set off in nervous pursuit of a look or a gesture which will, so far as these things can, reveal a life, or at least betray some careful concealment.

This is a book of photographs which ages consistently. From Baby Tarzan confidently protected by the mother ape, through the clear eyes of children and the small, supple bodies of dancers and gymnasts, to the greater

relaxation, the look of, 'Well, there, I did it, didn't I?' which old age often brings, this is a chart of the innumerable ages of men and women. The myth that beauty ends at thirty, being inextricably linked to unlined skin, clear teeth and a talent for water skiing and disco dancing, dies in these pages, where the most beautiful faces seem to be at the end. Madame Rambert giggling, Dame Ninette de Valois showing a great deal of lipstick and authority, Malcolm Muggeridge Puckish or William Walton pensive; none of these faces has lost anything with the years, rather they have gained. Perhaps they face the camera with more interest because photography has not, in their lives, been an every day occurrence, like music in the lift.

How far are the sittings successful in detecting the truth about a character? Are these carefully taken portraits all studio performances, tactfully, if nervously, directed from behind the camera to a number of actors, professional and amateur, who know how they think they should look and are delighted to go ahead and look it?

I always think we underestimate the amount of acting that goes on in what is known as 'real' life. In law courts the judges are acting being judicial, the barristers are performing anger, or outrage, or man of the world common sense and charm, the prisoners on trial often come on as cheerful Cockney character actors, a turn which they think may go down well with the jury. The jury members also, who may have been telling rude stories and discussing their cars in their room, immediately act the parts of solemn and respectable citizens with a heavy public duty to discharge as soon as they file back into court to deliver their verdict.

We are brought into the world by doctors, totally at a loss for a diagnosis, who know how to act a reasonably confident bedside manner. We are taught by school masters whose acting is designed to conceal the fact that they can barely keep a chapter ahead of their pupils. Our parents are adept at performing troubled responsibility for the benefit of their children at the moments when their own lives are at a peak of chaotic mismanagement, and our sons and daughters have learnt how to give a cunning impression of teenage rebellion from a thousand movies and television sagas. With all this acting about in the world why should not the sitter perform as usual for the benefit of the lens?

Of course, the enquiring photographer must hope to establish some truth behind the performance. The sitting chair, appearing in the empty studio, must be not unlike the client's chair in a barrister's chambers, or the seat of the suspect in a police interrogation, it has the same feeling of carefully organized isolation. And there are certain parts of sitters that can't lie. No doubt the face can be endlessly deceptive; the eyes, although Snowdon

himself says they are of the greatest importance and he always asks his sitters to look into the camera, can express candid innocence in the most devious witness. However, it is difficult to lie with your hands, with the shape of your fingers or the marks of your trade. Conan Doyle picked up during his medical training, and passed on to Sherlock Holmes, the trick of reading his subjects' lives through their hands. So these pictures start with some hard reality in the hands of Henry Moore holding stone, or those of Yehudi Menuhin pressing strings, or of Murray Perahia poised over the piano; perhaps the most extraordinary being Nureyev's foot, creased, scarred and stretched almost out of recognition in the painful search for artistic prowess and success.

And so we turn from the painful truth of fingers and feet to the various performances of faces. It is quite possible to tell what some of these sitters have decided to create as well as the characters created for them. Some of the actors have settled for looking handsome, the young girls for looking young. Perhaps the most successful performance is given by the editorial genius of Harold Evans, who appears to have produced a large standard typewriter with the triumphant flourish of a North Country conjuror pulling strings of sausages and the flags of all the nations from a manifestly empty hat. I don't know how much this magnificent pose is the result of the photographer's direction, or how much is due to natural dramatic ability. The result is a performance so apt that truth and invention mingle and character becomes indistinguishable from character acting. It is noteworthy that Mr Rupert Murdoch, on the opposite page, has chosen to adopt a pose of quite hard-bitten and world weary Australian cynicism.

It is interesting to discover what sort of character the sitter decides to present to the blank eye of the camera. There is a great temptation to appear as an enormously cheerful person, a jolly and carefree chap or an endlessly laughing girl, encouraged by certain photographers whose sitters always seem to be saying 'cheese' or 'shit' according to their age and inclination. Politicians, particularly American politicians, are always snapped grinning hysterically when about to discuss such subjects as mass unemployment or the nuclear holocaust; such expressions of glee add greatly to their sinister and depressing appearance. English politicians may feel, wisely, that their electorate doesn't require a government of cheerleaders or stand-up comics; and Mrs Thatcher seems to have decided on the expression of an intelligent but hard done by heroine of the Greer Garson era (it's been tough going, but thank God she's kept her sense of humour), and Mr Foot looks quizzical enough for the literary pages.

Some sitters have the advantage of props, the Archbishop of Canterbury

and Erté, the ageless French designer from the golden days of *Vogue*, have the support of costumes, the Prince of Wales is allowed to fulfil some dream of appearing as a Victorian jockey, and Sacheverell Sitwell can flourish a rakish walking stick. Sir Alec Guiness indulges in a most curious hat, which is presumably the excuse for his smile of impish apology. More usually the sitters enter the small studio, it is too short a room to allow of a full length portrait, with no protective clothing except their own idea of themselves

During a sitting Snowdon is at first, in my own experience, as nervous as a writer in front of a blank sheet of paper, or an actor at a read through. The awful moment of decision, of ruling out alternatives and starting work, has to be postponed for as long as possible. The London daylight is reflected by white boards outside his studio windows, and is applied to the dark walls of the room as paint was once used to highlight a dark canvas. There is not a great deal of chatter, although he has taken pains to find out all he can about his subject. The natural light means a long exposure and an unblinking look from the sitter, not for as long as in the great days of nineteenth-century photography when the subject's head was fastened into a kind of vice, but still long enough to provide a small test of endurance. Instant polaroid pictures have been taken, but the sitter is never shown them. He can only guess, as he stares, dry lipped and unwinking, into the dark eye of the camera, as to what view it might be taking.

There is no doubt that the photographer has seen something, a picture in his head, before he started to work, just as the sitter carries about his portrait of himself. How exactly these two pictures come to mingle must remain something of a mystery, I suppose it must be much as the actor's and the director's idea of a part slowly come together. Whatever emerges can never be entirely what each party had in mind. As a small instance I cannot tell whether Snowdon saw me, or I saw myself, as a somewhat disgruntled archdeacon. It's not a role I play often, but I must have fallen quite naturally into it in the chair.

Sometimes the acting is naturalistic. Ben Travers is exactly as I remember him, cupping his ear to catch every syllable and about to say something wonderfully rude. With others it is superbly theatrical; John Betjeman, left alone at the end among the shrouded furniture, looks into the future with the sort of wistful ruefulness of expression which he clearly finds gently entertaining.

It is a fallacy to suppose that the way you look is something you are entirely stuck with, immutably, from birth. Everyone spends a lifetime working on their appearance, and in this book the photographer and the subject are seen working it out together.

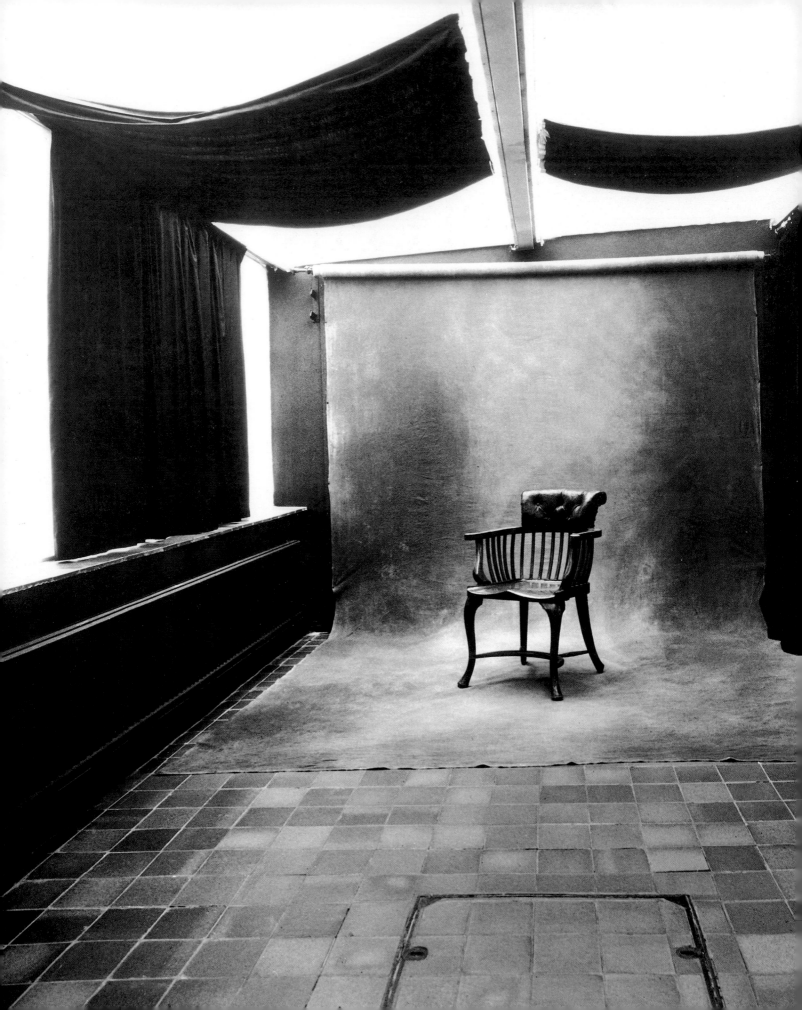

SITTINGS
SNOWDON

The word studio to most people means a huge, high ceilinged white-washed space with a north light. If it is used by a photographer it is usually filled with spotlights, floods and electronic flash. My first studio in Pimlico, where I worked throughout the Fifties, was a converted ironmongers' with no daylight. I tried to simulate natural light by building a large aluminium box filled with about 60 electric light bulbs covered with tissue paper. My studio today is even smaller; it's the size of a lean-to greenhouse: 10 feet wide, 14 feet long and only 7 feet high – not by desire, but because of building regulations. A rather grand photographer came and spent several hours with me one day recently. Before he left he said, 'But I came to see your studio'. He'd been in it for two hours.

There is something to be said for the studio not being very impressive: sitters are not too intimidated.

My studio, 1983

And if everything was ideal I might settle into a formula and every picture would be lit in exactly the same way. It faces west, completely the wrong direction for constant light. There's ordinary greenhouse glass on the roof, but I've pinned two layers of frosted plastic to diffuse the daylight. I use polystyrene reflector boards, white on one side and black on the other, putting some in the garden to boost the light from the side.

I have dozens of different backgrounds, all of which look almost the same. A background has to be just on this side of being something, and just on that side of being nothing: you can only use it until it becomes recognizable, then it's past its usefulness. Within the emptiness and the terror of a plain background I try to capture something which is not only a likeness of a person but says something about them. I want my sitters to be recognized, not my work.

There are usually no lights in the studio because I infinitely prefer daylight. Black velvet curtains down one side cover the windowless wall, and I use black blinds on rails to change the direction and the amount of light. Every surface in the studio that is not glass is painted black. I find it easier to add light rather than subtract it.

When I was interviewing a very successful photographer called Madam Harlip for a television programme she told me that she painted with light like Rembrandt. I said I thought that surely in the 17th century he must have used daylight. 'Yes, daylight is all right for the painter but not for the portrait photographer. I know you use it, but you are more for the snap shot!' She was quite right. I am all in favour of the 'snap shot'.

All photography is about really is snap shots. It's capturing a moment that is typical. The photographer is essentially unimportant. It is the subject that is being recorded that is all important. Great photographs that are remembered and illustrate a moment of history are those which have frozen a moment of emotion, of sadness, of happiness – photographs that stimulate an emotion in the viewer. Portraits of people taken in a studio seldom do that; they are purely a record of the sitter and will only be interesting to future generations because of the face and expression of the sitter. Their only lasting quality is likely to be that they serve as a record of the people who other people wanted to see at a particular time. That is partly why I prefer to work for magazines rather than private commissions. I don't want the sitters to choose the picture because they are seldom the best judges.

Being photographed is a bit like being in the electric chair; nobody likes it.

I think the only way you can learn about taking photographs is to be photographed yourself so you can see what an awful experience it is. Nothing is more nerve-racking than a stream of ludicrous small talk from behind the lens. The whole process is embarrassing and can often tell truths that people want to hide. Most of the time my eye is close to the viewfinder; I am seeing the sitter through the ground glass screen. There is no direct eye contact; it is like seeing them on a television screen. I nearly always want their eyes looking directly into the lens. A lens is a frightful, powerful, horrible machine, and the people who are being photographed usually want to escape from it. And because they are shy or embarrassed, or at a disadvantage and trapped, sitters will try to escape by making eye contact with anyone else who is in the studio. That is why I need absolute silence – rubber soles for me and my assistant whom I expect to be even more inconspicuous than I am. I never want an assistant to talk technical jargon or catch an eye line. The relationship between an assistant and myself is schizophrenic. During the session I expect him to be anonymous and then at lunch or supper afterwards I like him to be an extremely firm critic, an amusing companion and a fund of technical data mixed with spicy gossip.

The exposures that I use are often half a second or more, which is hardly freezing a moment in time; yet that agonizing slowness and silence sometimes helps accentuate certain mannerisms. In the studio I nearly always work with a medium sized camera ($2\frac{1}{4}$ inch square), which gives a certain formality. In this book there are no long lenses or hidden cameras. There is no doubt in the sitters' minds that they were being photographed.

I always start by taking polaroids – for three reasons: first to let me know the shutter is working; second to show the effect of the lighting; third, to check on composition, like the picture of Sarah and Andrew with the doll (page 25). The expression on the polaroid isn't important; that comes later.

I never like to prepare the studio before a sitting. All the manuals say you should have everything ready before your sitters come, so that they will not get nervous hanging about. They also suggest that you should talk like mad to make a relaxed atmosphere. I find I don't do this. I don't want things to be too relaxed. I think it's important to have nothing prepared but rather to start off with an empty box and built it up from nothing each time. This is why I find that perhaps the most important aspect of taking photographs of people is to find out as much as possible about the sitter.

If I'm driving down to photograph somebody on location with an editor

or assistant, I don't want to talk about the price of petrol or how difficult it is to get out of London, I only want to discuss the person I'm going to photograph – not *how* I'm going to photograph them, but talk about them, their career, their achievements, their work and their life.

On location I nearly always find the background too busy, and end up rearranging a room and taking out anything distracting. I prefer to find a plain space which I use like an improvised studio. The limitations sometimes work to my benefit. I often end up in an attic using the light from a skylight or in a garage with the doors open.

I like to direct my subjects and tell them exactly what to do. It is not always a matter of making people feel totally at ease. Often the only way that one can break through someone's prepared face is to make them slightly uncomfortable, physically or mentally. Sometimes people can be awkward or ill at ease in a way that expresses themselves better than when they are relaxed. I may, perhaps, ask them to hold a pose for longer than is natural, or I make a remark about the sitter or their work that surprises them, and then watch for their immediate reaction. On the other hand, I sometimes ask someone to move fractionally, not because I know what I want them to do, but simply because I do not like what I'm seeing and if the person moved I might like it more. Only when things are going badly do I use the tactic of talking; it is a conscious and artificial device and I only listen to what is said in the hopes that an idea will come out of it; sometimes I leave the sitter alone for a few minutes to change the mood.

Often when people are told exactly what to do they become more themselves than they know. In contrast, of course, it is crucial with children and the old who tire quickly, to work fast and get the shot before they shut down like a machine which is turned off. One of my worries comes when the eyes go dead and people go blank. If this happens we have coffee or change the location and start again. The collaboration between the sitter and the photographer gives the photographs whatever spark of life they might have; it is the coming together of the way the sitters choose to show themselves and the way I choose to show them.

Some people are very concerned about their appearance and arrive in their Sunday best so that they can be recorded for posterity as they think they ought to appear. Their choice of clothes is often too formal. A dark suit, white shirt and tie is my least favourite, along with stridently patterned dresses or blouses. I prefer overcoats, open-necked shirts and plain colours.

14

Tali McGregor as Tarzan and Ailsa Berk as Kala in
Greystoke : the Legend of Tarzan, Lord of the Apes, 1983

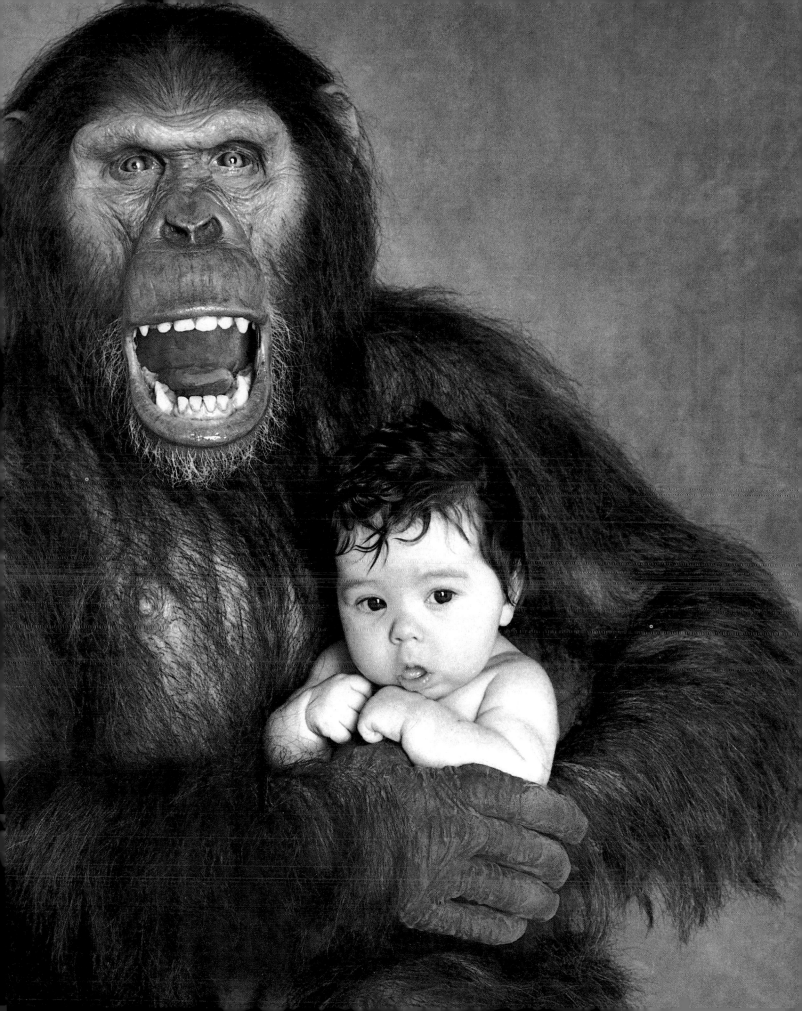

I want the viewer to be unaware of clothes unless they tell me something about the person. That is why I'm such a bad fashion photographer.

Luck plays a big part in my kind of photography. Chance can happen to anyone; luck is different. There's the luck of capturing a particular movement that may not be repeated. You may have got the wrong lens, then something happens, and you find you've got the right one for a picture you would never have got by calculation. Occasionally luck works for you. It may be simply being ready for an uncontrolled movement in a controlled situation. I would never have planned photographing John Betjeman surrounded by dust sheets (page 141). It happened at the end of a sitting for a group of writers. John Betjeman was left behind for a moment in an empty space.

I find it's very important to see other photographers work to admire, but hopefully not to copy. I particularly admire Irving Penn for his elegant and simple portraits and fashion pictures, Cartier Bresson for his legendary reportage, Angus McBean for his theatre photographs, the work of Bill Brandt, and the much-underrated work of John French who was really the first person to use bounced light with such expertise. If any of their considerable talents has brushed off on to me then I'm more than grateful.

I don't like talking about my work. I prefer people to come to their own conclusions. I do not think that photography is one of the fine arts. I think it is one of the applied arts. In fact I do not like the word 'arts' at all. Neither do I like having discussions about the 'inner meanings' of photography and all the other mumbo jumbo that is talked about it. If there is a good thing about photography, it is that it can be easily enjoyed. Some people want to veil it in mystery but they should be regarded with deep suspicion it seems to me.

On my way to photograph Henry Moore recently, I was reading what he had written about himself: 'You don't set out to go in any one direction. Instead you respond to whatever influences come into your experience . . . I try to be direct and practical in all my work. A sculptor has to be because so much of his work is essentially practical. It's no good him being just a theoretician. His ideas have to end up solid. People should not be impressed by things they do not comprehend, and should certainly not permit themselves to be belittled by them. Obscurity for its own sake only impresses fools. At the same time I do not mean that everything needs to be obvious. In making sculpture I do not think in words, I think in shapes. If something is wrong with a sculpture, I know it and try to make it right, not

by logical argument, but by a process of eliminating what is wrong. Your past controls your future. You cannot escape it. I don't want to know how I work. I would hate to be psychoanalysed. If I am abnormal, that may be my contribution to society.'

The sculptor has to sustain his inspiration right through an arduous and time-consuming process, whereas the photographer is dealing with split seconds, and I feel that, with very few exceptions, this speed robs photography of its ability to express things profoundly. The best photographs are not those which vie with painting and sculpture, but those which sum up in a moment more than that moment, which pin down a style or attitude.

Most photographers of my age started taking photographs because they failed at something else. I failed as an architect. Photography only became an acceptable job a few decades ago and I fear that now it's all too serious. For me photography is a way of recording things because I can't draw. I think 'portrait' is a tiresome word and makes a false analogy between photography and painting. The biggest insult, as far as I am concerned is if someone says, well-meaningly, one of my photographs is like a painting. I suppose it's as insulting as it would be to a painter if he was told his painting was just like a photograph.

Work has to be fun. It's a difficult and curious balance. It's all games. I need to play games, but professionally. The game is up when your work is published. After taking photographs for thirty years I suppose I should have gained more confidence or got better at it, but I find neither has happened – the dread of starting is just as bad, the disappointment on seeing the results is even worse.

Christopher Lambert
and Andie MacDowell
as Tarzan and Jane in
*Greystoke: the Legend of
Tarzan, Lord of the
Apes*, 1983

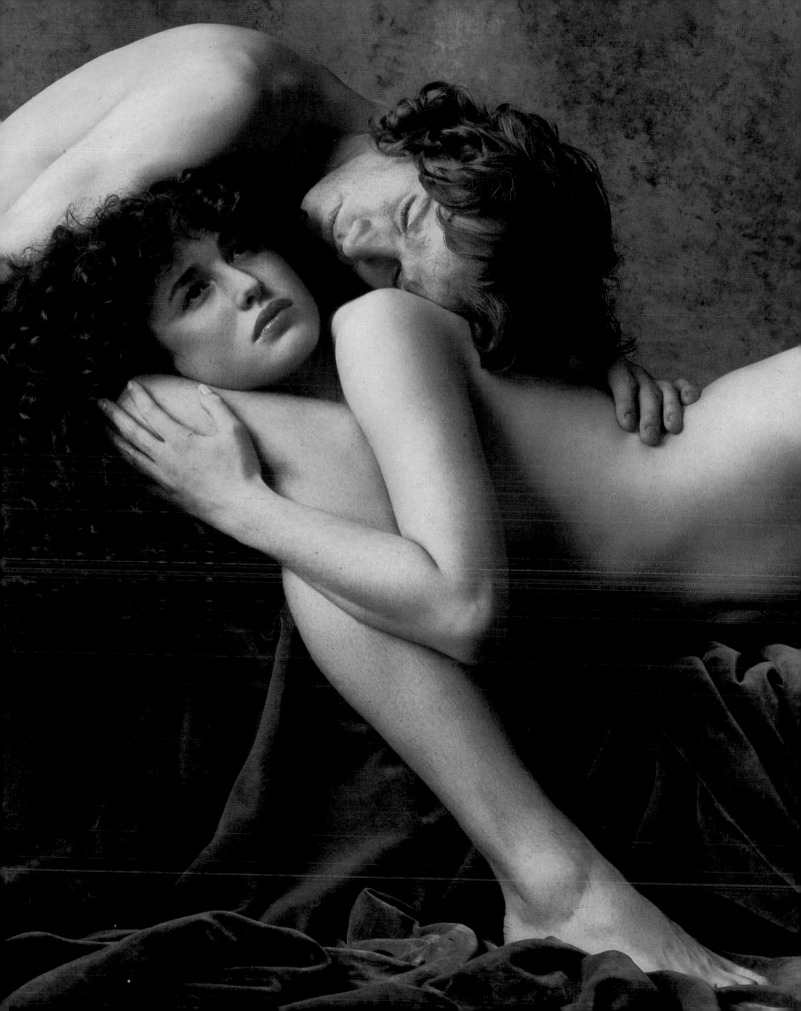

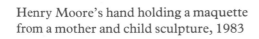

Henry Moore's hand holding a maquette
from a mother and child sculpture, 1983

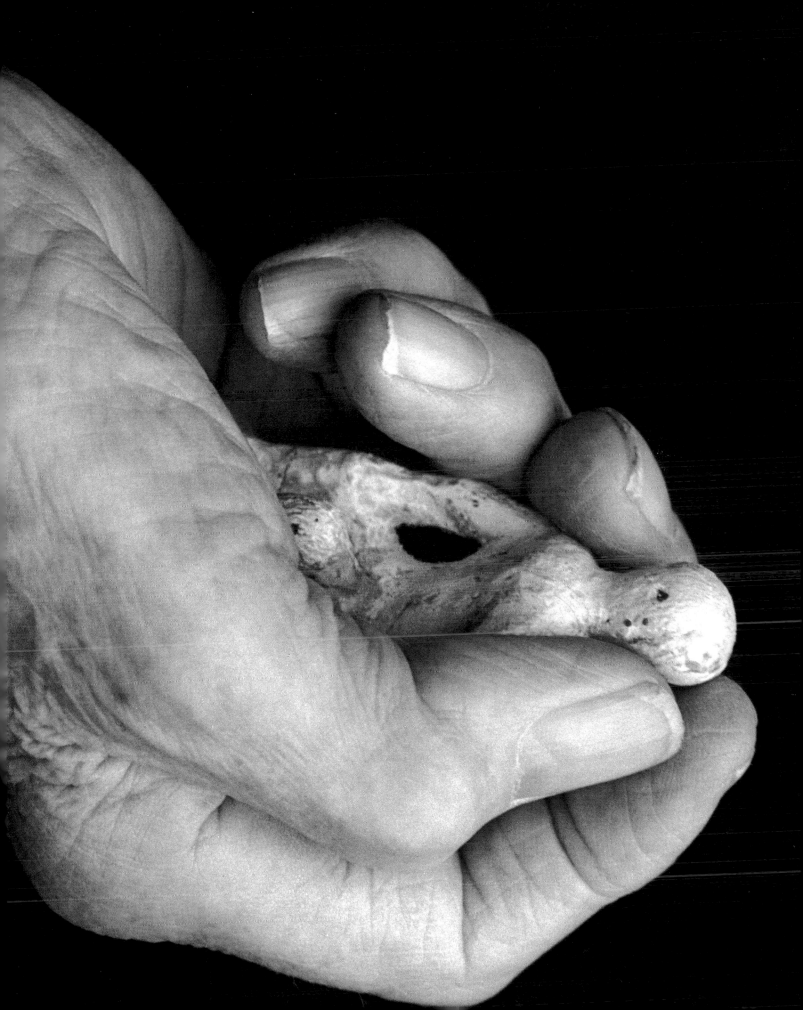

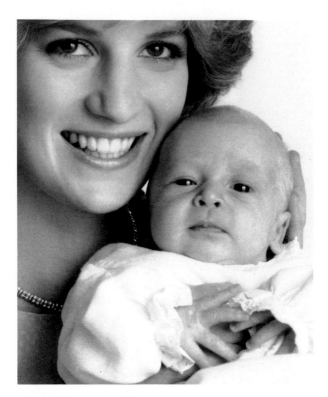

The Princess of Wales with
Prince William aged three weeks,
July 20th, 1982

The Prince of Wales in his racing colours, 1981

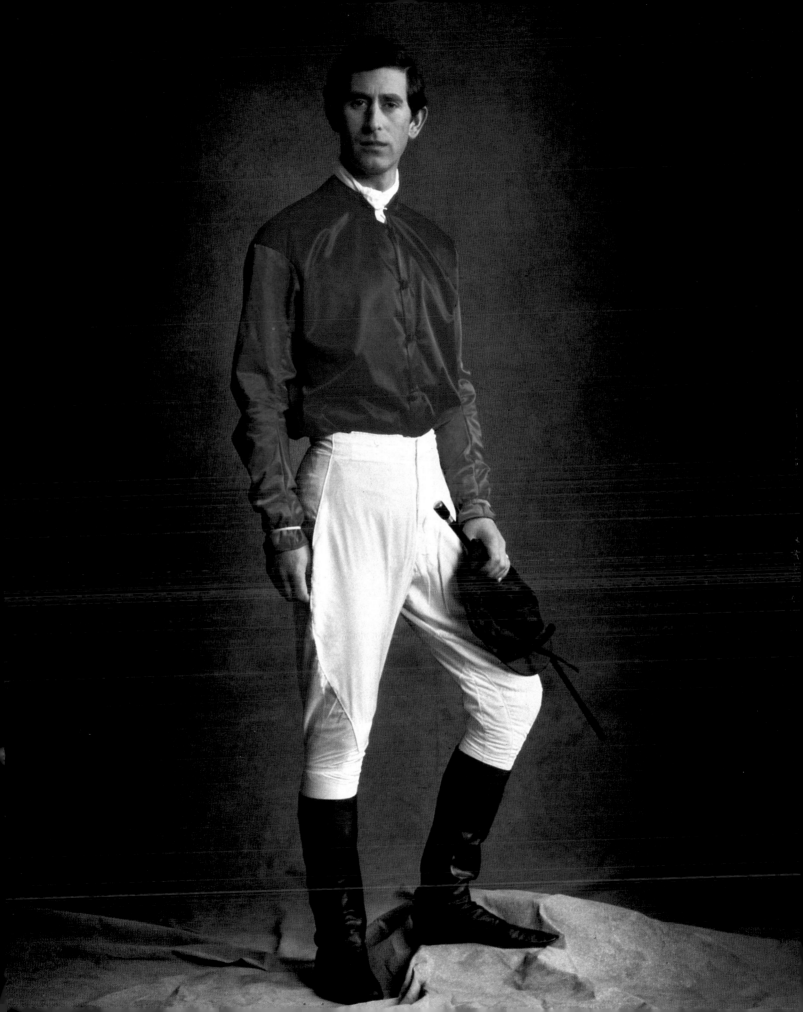

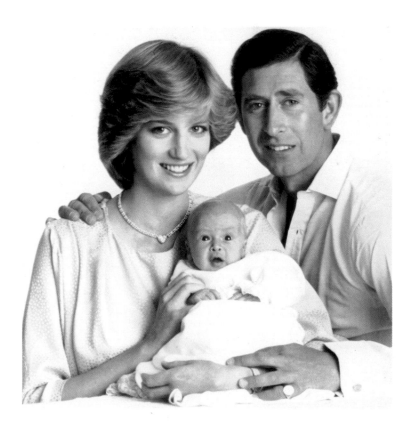

The first photograph of
Prince William, with his
mother and father, 1982

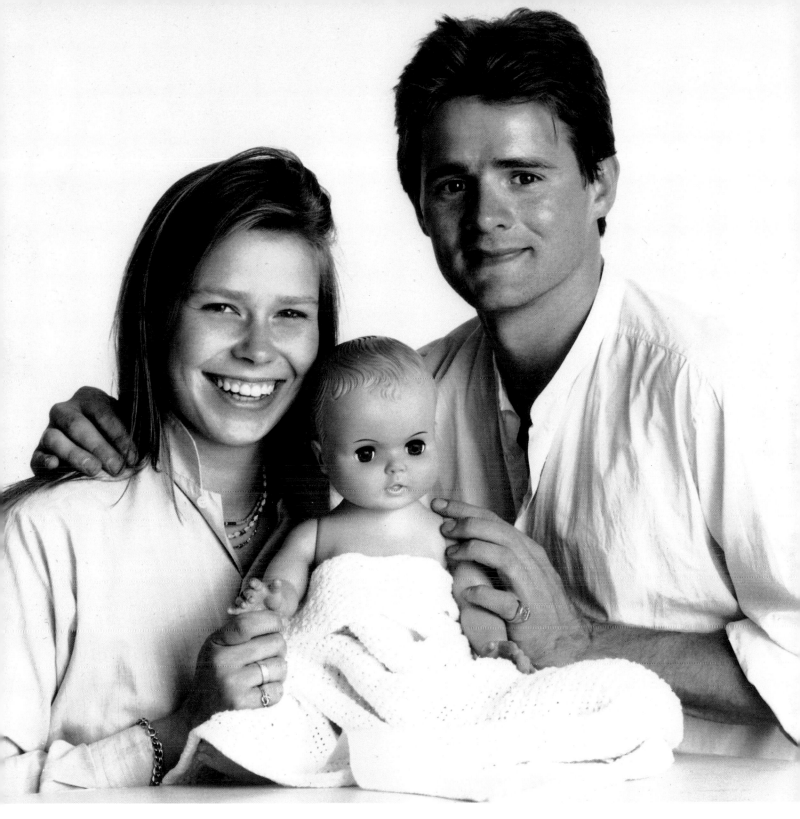

My daughter Sarah and my assistant
Andrew Macpherson rehearsing the day before,
for the picture opposite

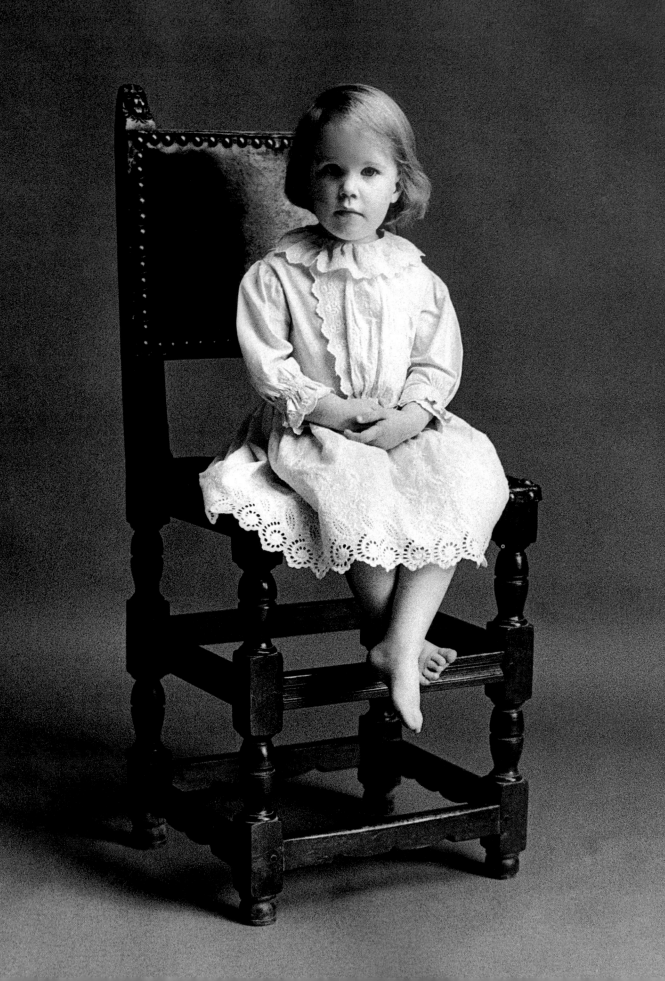

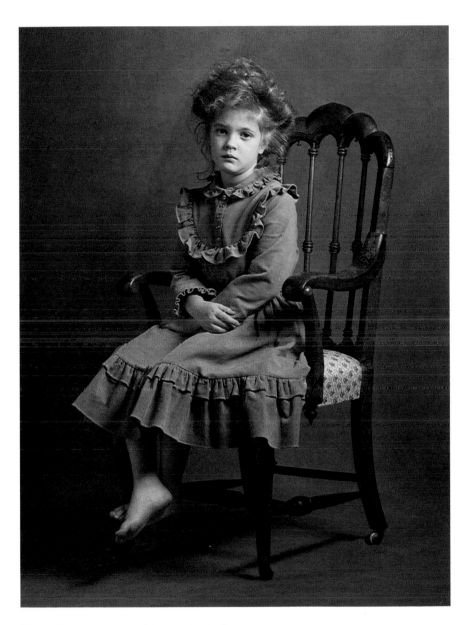

Drew Barrymore aged 6, nominated
for a British Academy award as the
most outstanding newcomer for her
role in Stephen Spielberg's *E.T.*, 1982

My daughter Frances aged 3, 1982

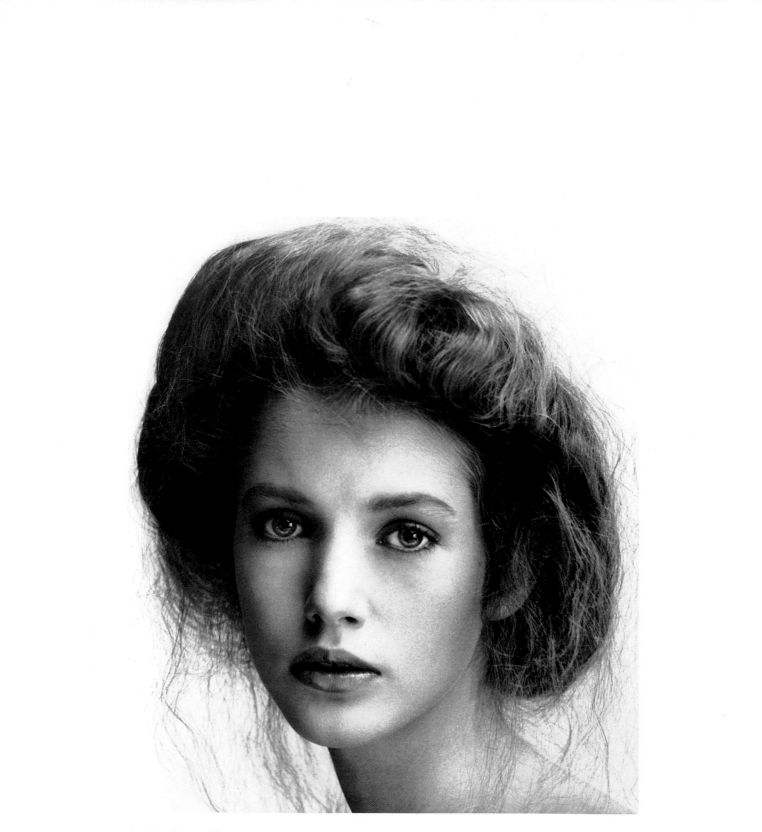

Cecilia Chancellor aged 16,
a student at St Paul's Girls School, 1982

The Lady Helen Windsor
on her eighteenth birthday, 1982

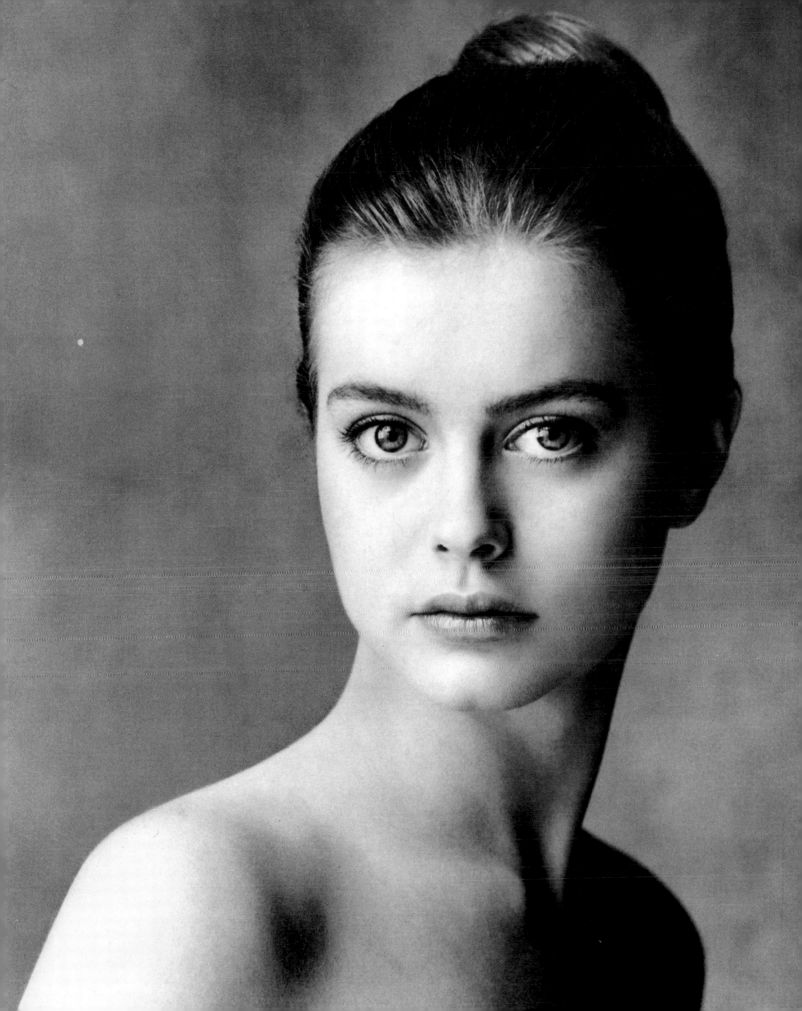

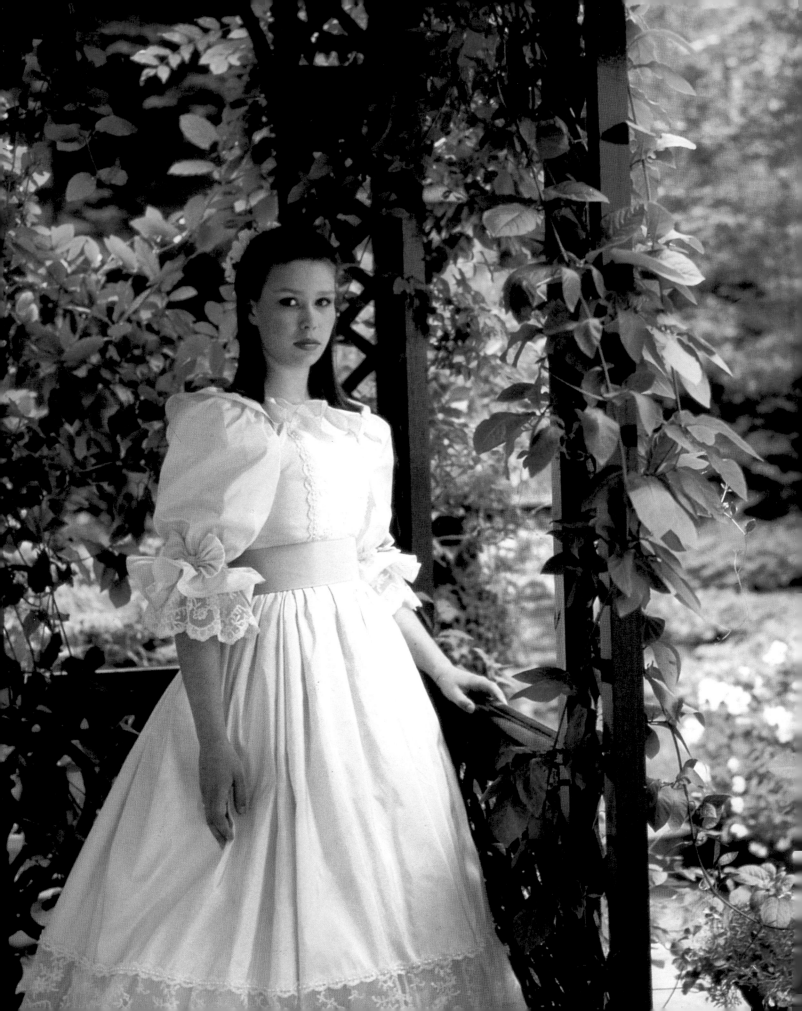

Photographing a close relation or someone you know too well is the hardest of all. Masks can't be worn; games can't be played. There is an embarrassing shyness on both sides of the camera. Although I love taking holiday snaps of the family, when I was asked to photograph my eldest daughter for *Vogue* we were both extremely nervous and embarrassed. If I had brought her into the studio in her ordinary clothes she would probably have sat down and giggled. The only solution I could find was for us both to be extremely distant and formal. We made the setting into a grand production with make-up artists, hairdressers and fashion editors to help make it impersonal; in effect Sarah became part of the environment. I suppose it's a kind of romantic escapism. It certainly is not freezing a moment of realism which is what photography should really be. Sarah doesn't usually stand on a balcony, made up to the hilt in a long dress looking very serious. But it's relatively harmless make believe, if somewhat over the top.

The photograph is in the same vein as the pictures of the Duke of Norfolk and the Archbishop of Canterbury (p. 125) where they almost get lost in the grandeur of the architecture and the Archbishop's outfit. The Duke becomes an emblem. They are almost architectural photographs.

My daughter Sarah as a bridesmaid in 1981

Sean Reason aged 11, at The Royal Ballet School,
White Lodge, Richmond, 1981

Minna Fry aged 17, student, 1982

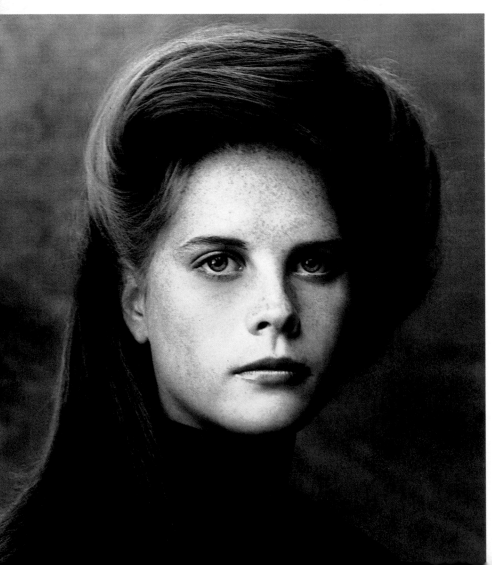

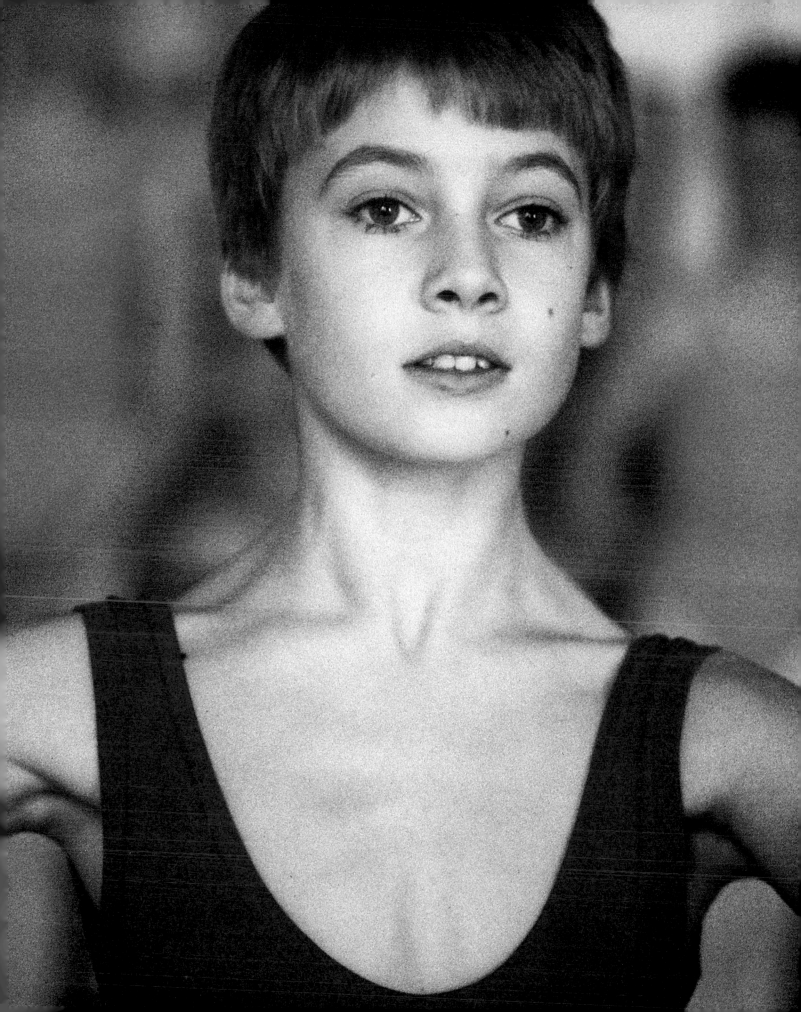

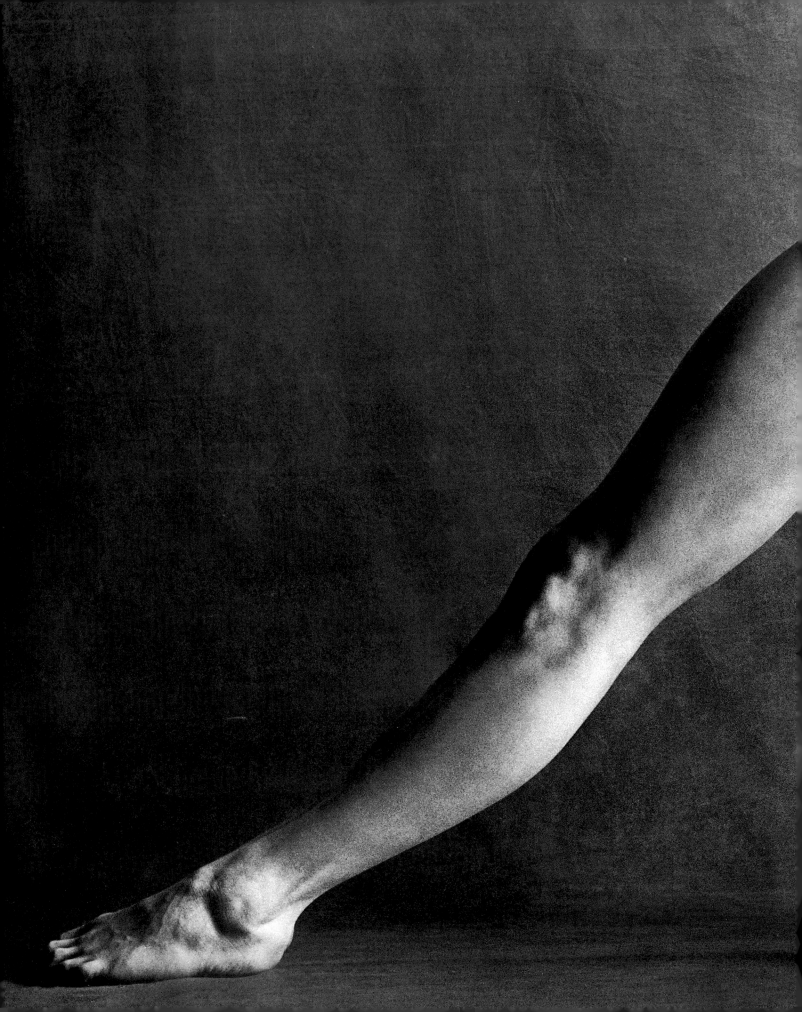

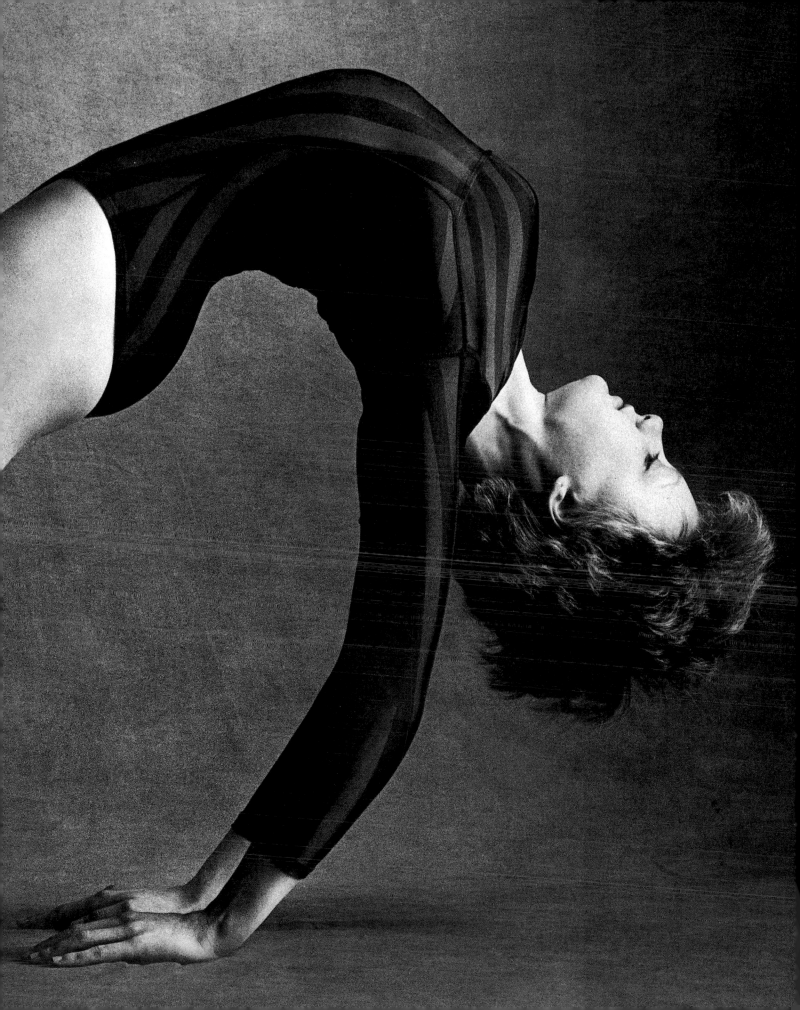

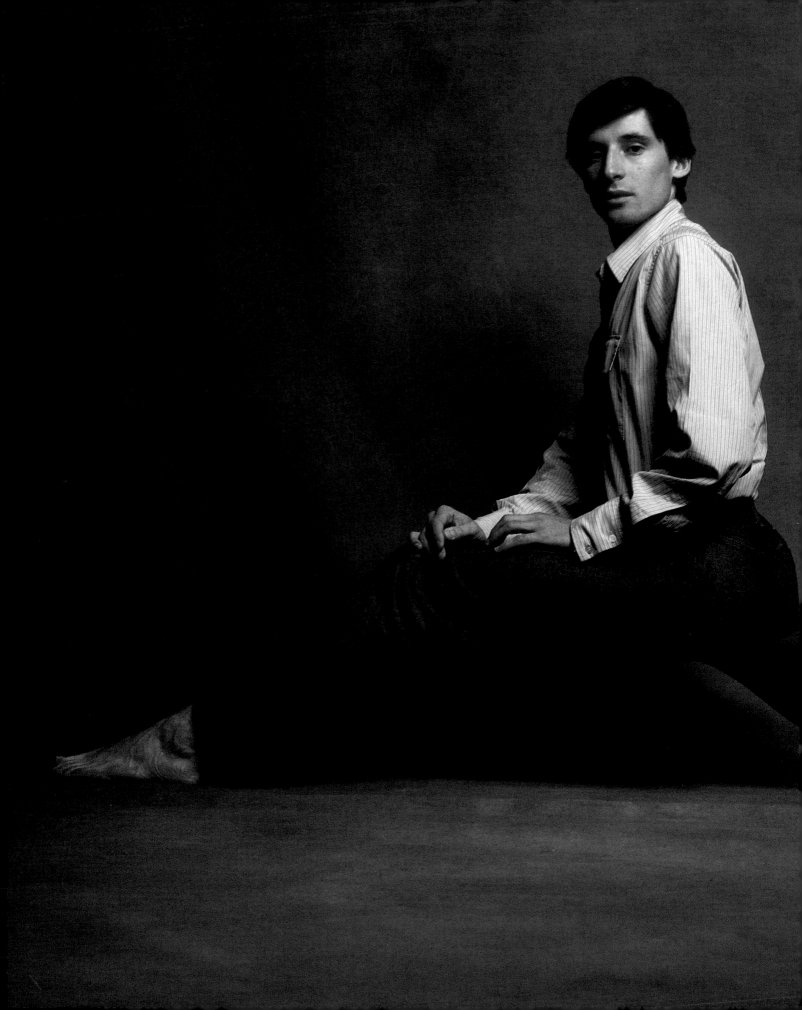

Previous page
Hayley Price aged 16, gymnast who
represented Great Britain in the 1981
Moscow World Championships

Instead of taking action pictures of
gymnasts and athletes on location, I
have tried to see what shapes their
bodies can make in the controlled
condition of a studio. There is nothing
to distract the eye in the background;
nor are they quite in these positions
when they are performing. I find it
fascinating to see the suppleness of a
sixteen year-old gymnast's back, the
shape of a boxer's shoulder muscles,
the span of a record-breaking runner's
legs and the contortions of a dancer's
body.

Sebastian Coe, Olympic Gold
Medallist, 5′9′′, has a stride of 7′6′′,
and holds five world records, 1981

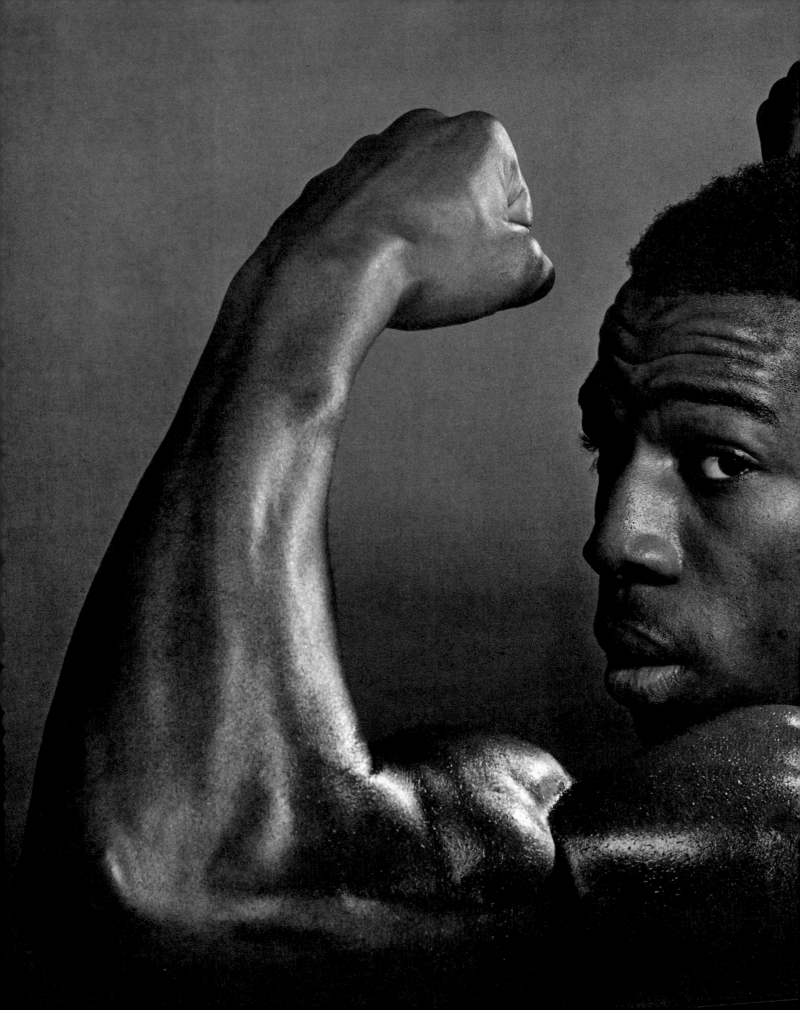

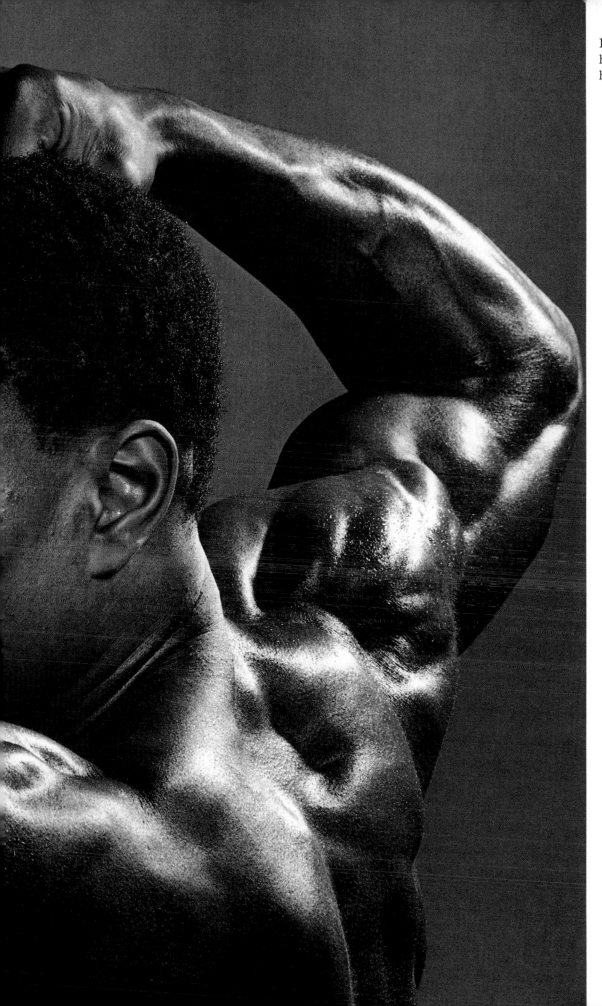

Frank Bruno aged 21, British heavyweight boxer who won his first sixteen fights, 1983

Wayne Sleep in a costume by
Ian Spurling for his show, *Dash*, 1982

Lydia Abarca, principal dancer with
the Dance Theater of Harlem

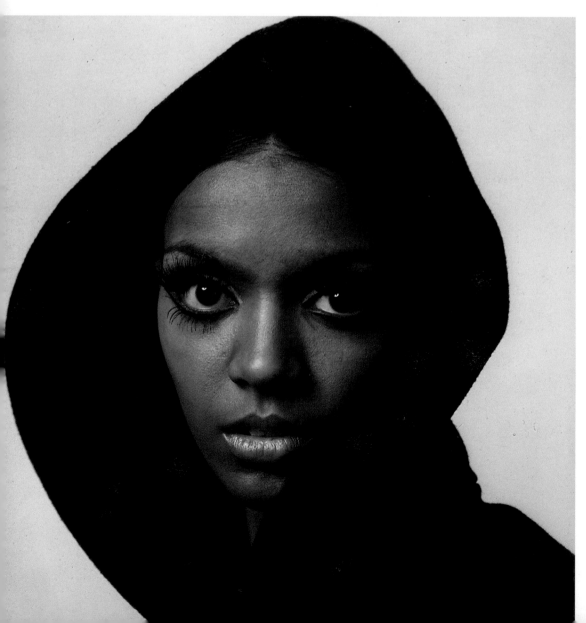

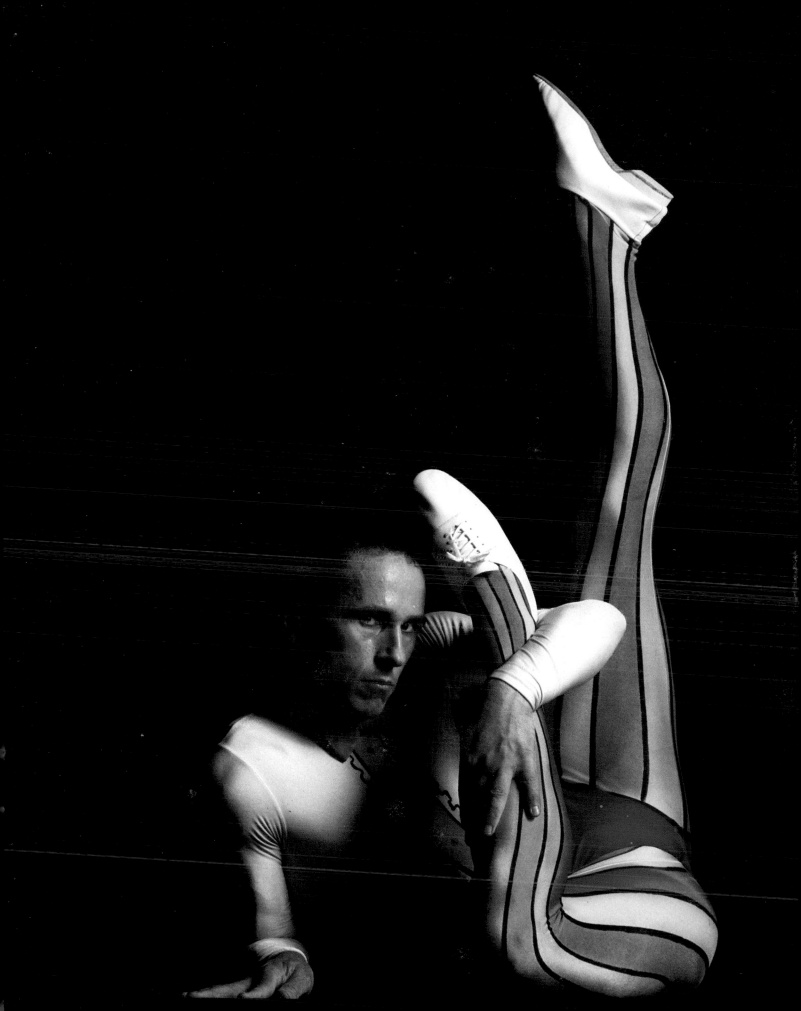

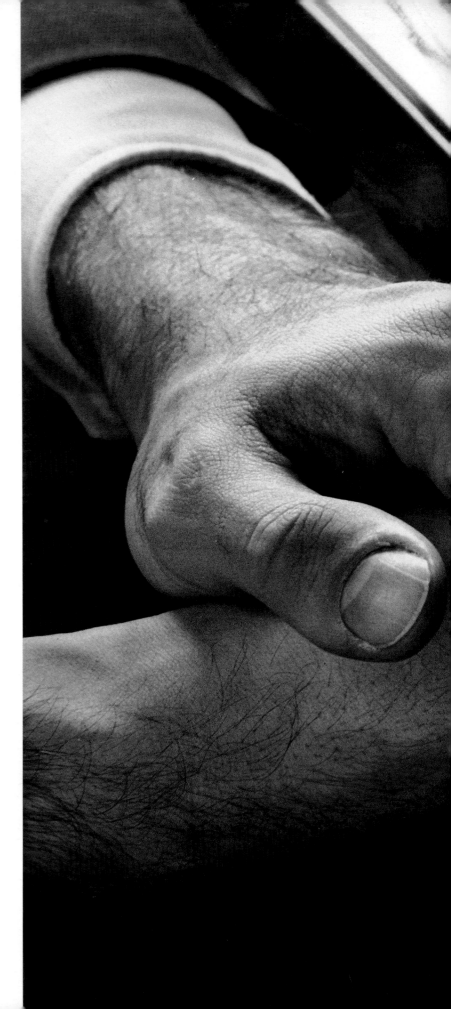

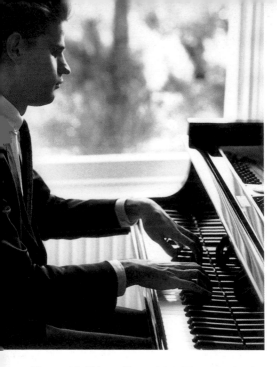

Bernard d'Ascoli aged 24, French pianist
and (*right*) his hands, 1982

Overleaf,
The Royal Ballet School,
White Lodge, Richmond, 1981

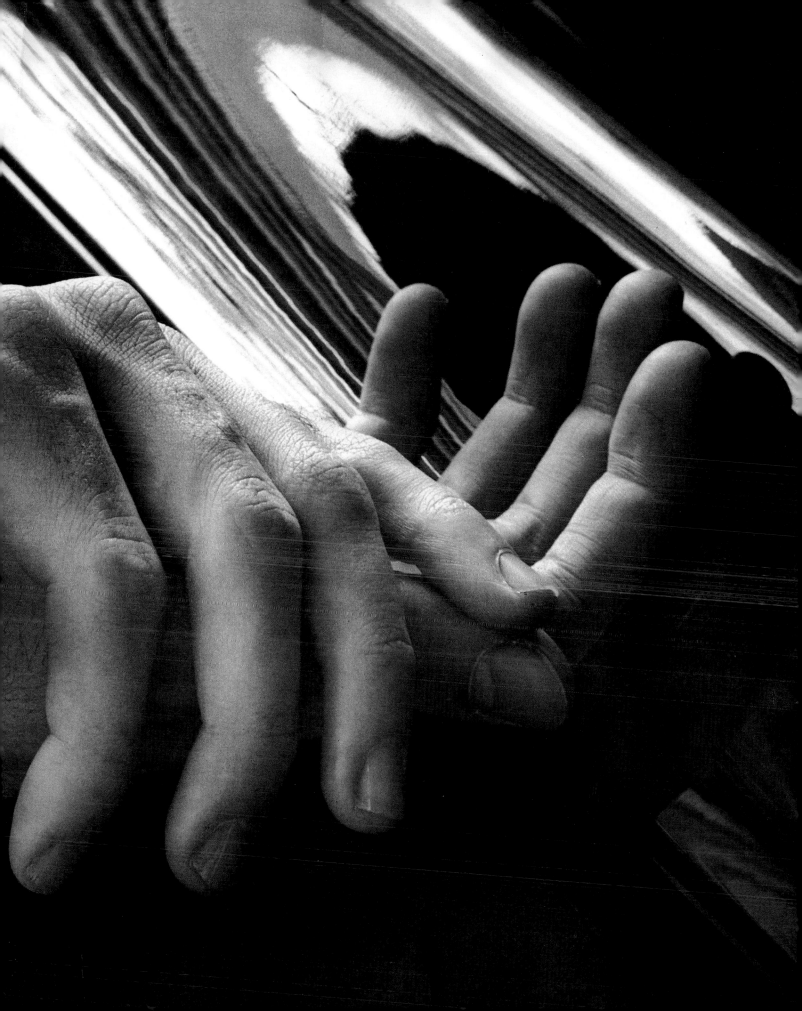

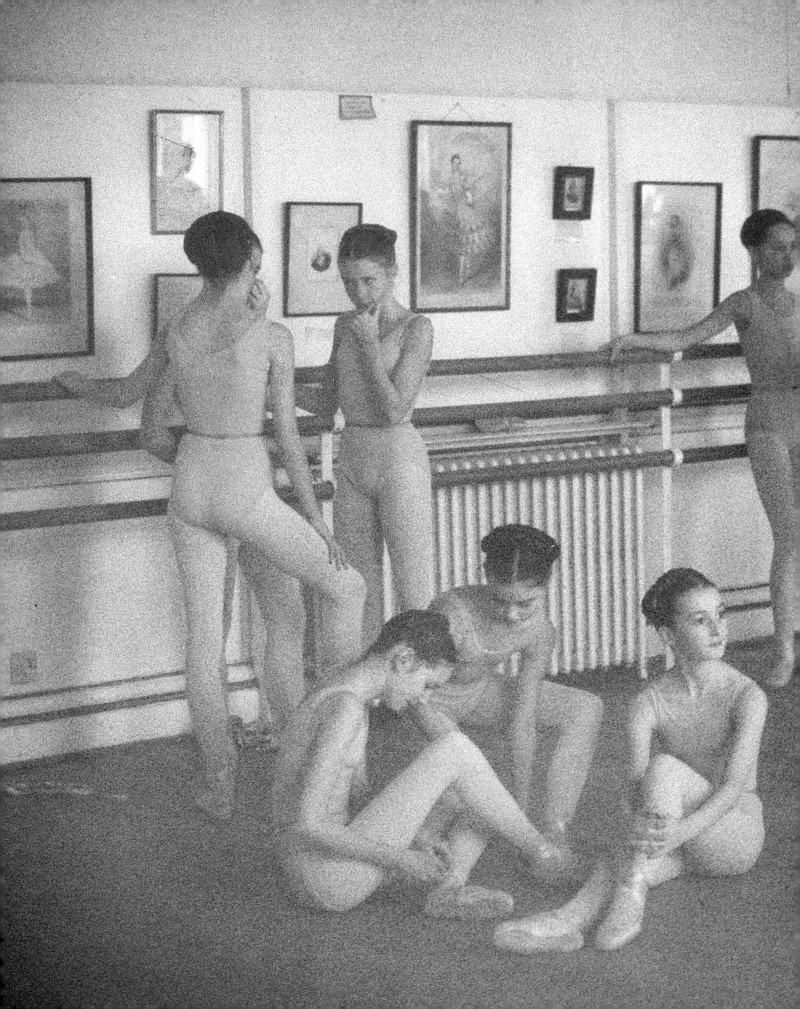

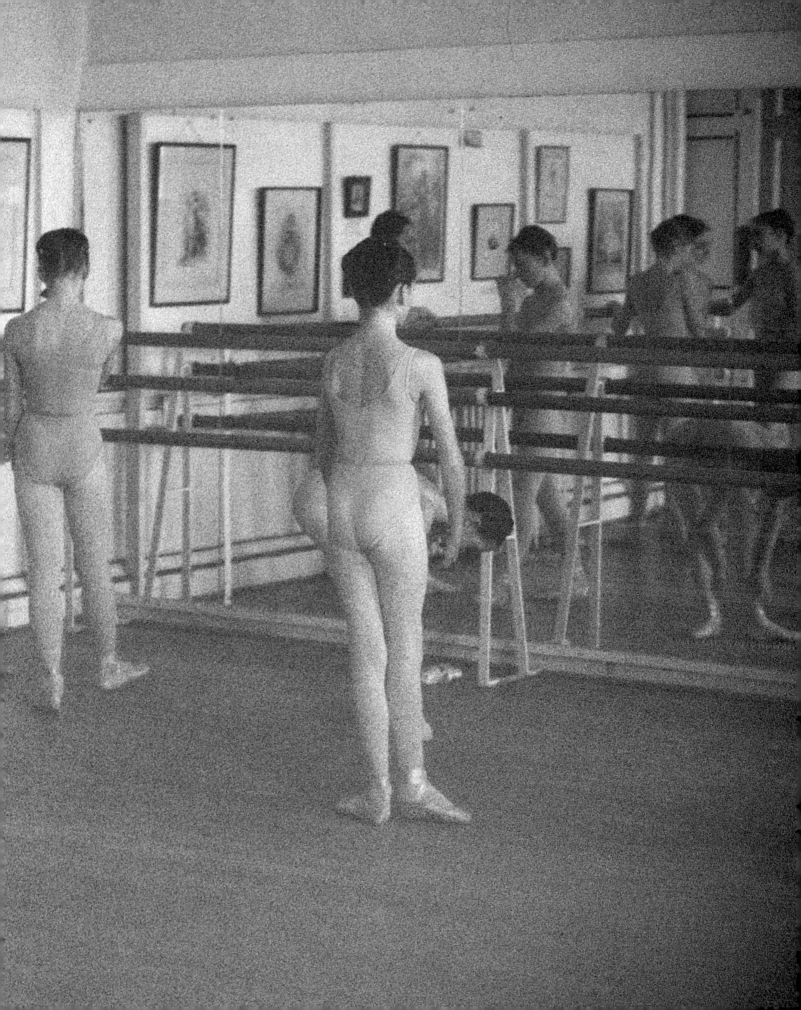

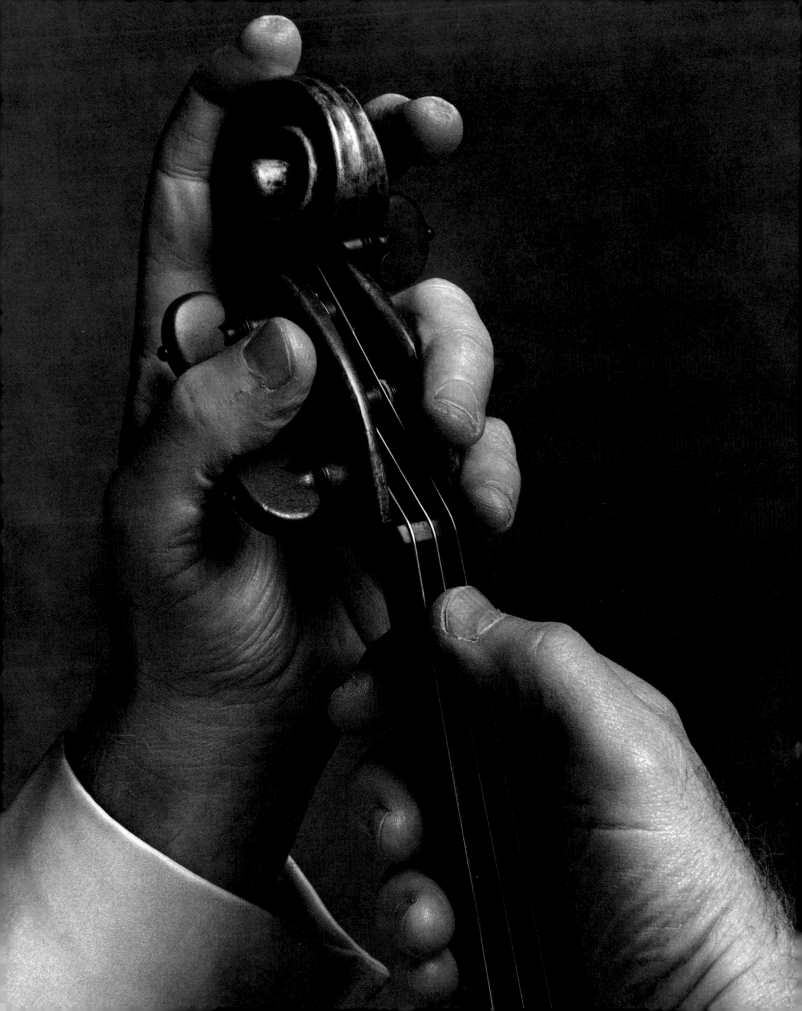

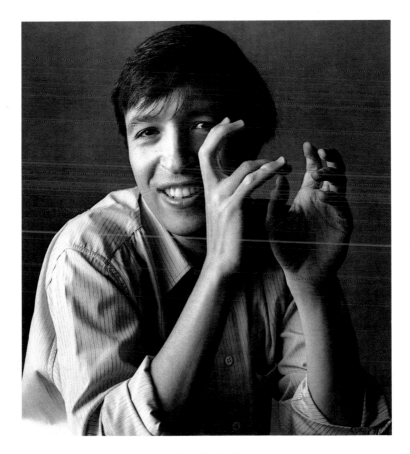

Murray Perahia, pianist, and artistic director
of the Aldeburgh Festival, 1983

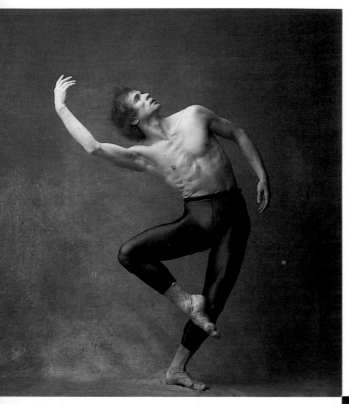

Rudolf Nureyev aged 44; in 1982 he
danced over 200 performances,
and choreographed *The Tempest* for
The Royal Ballet

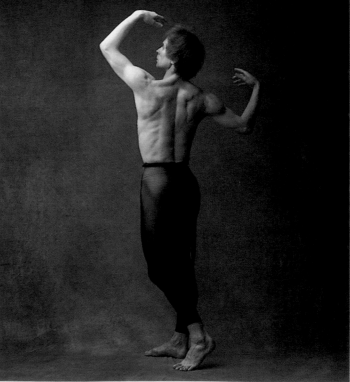

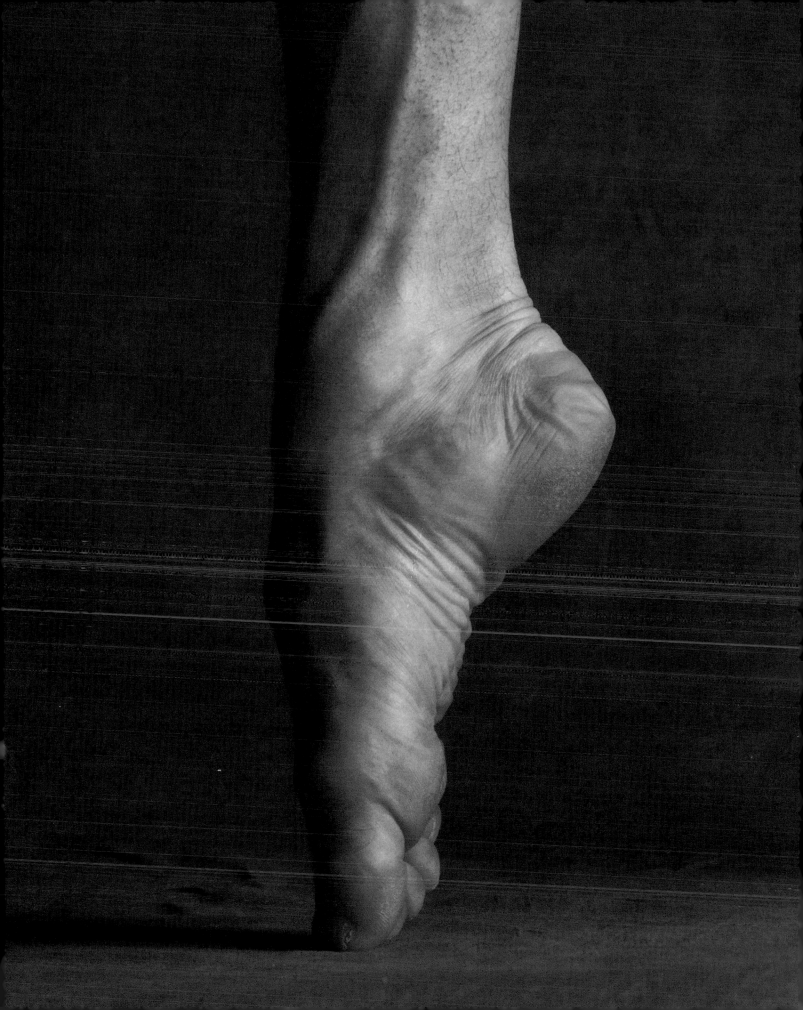

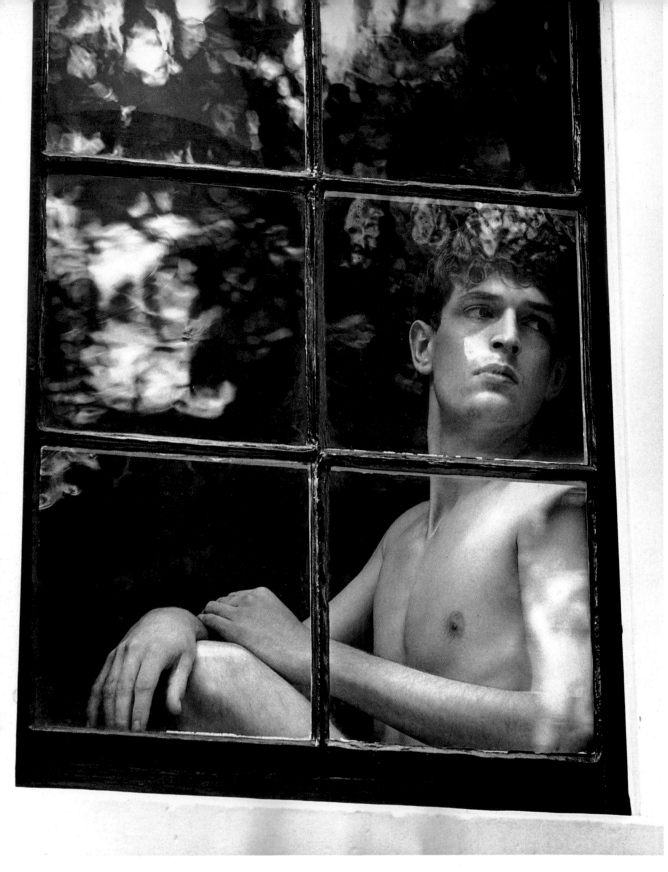

Rupert Everett made his first impact in
Julian Mitchell's play, *Another Country* 1982,
and later appeared as Lancelot in *Arthur the King*,
directed by Clive Donner in 1983

Jeremy Irons played Charles Ryder in
the television series of
Brideshead Revisited, 1981

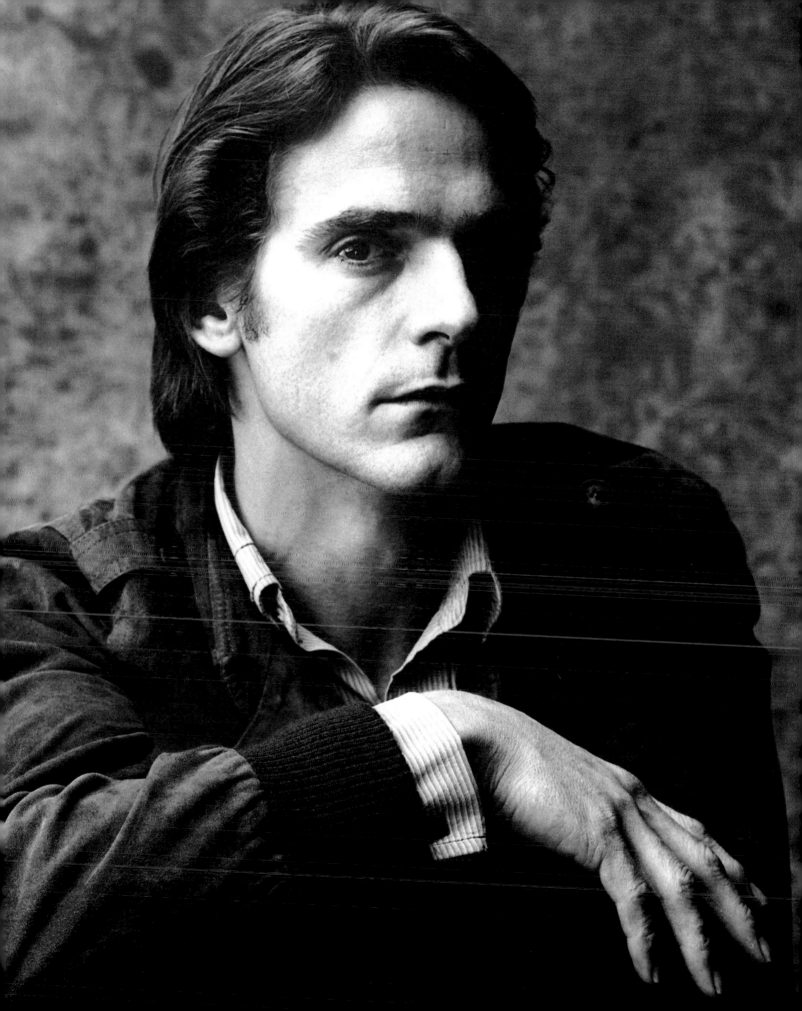

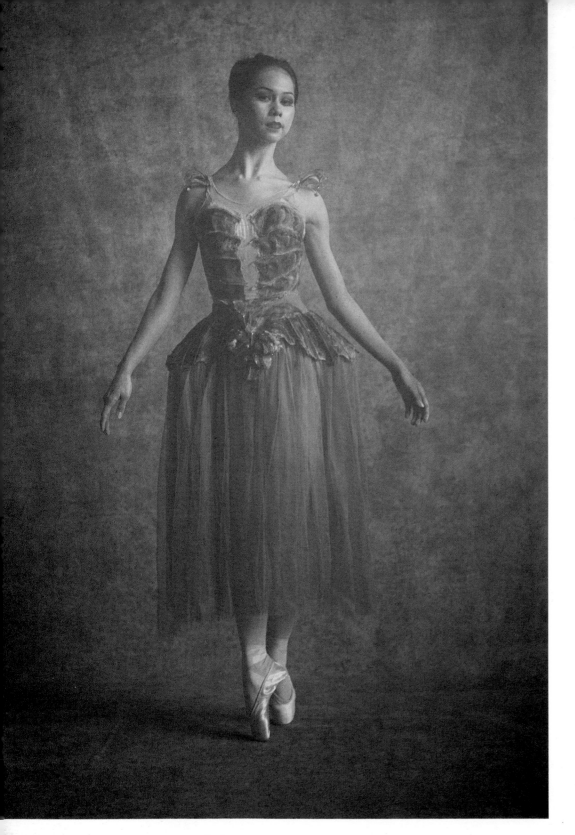

Ravenna Tucker of the Royal Ballet
wearing a costume designed by
Oliver Messel for
Homage to the Queen, 1981

Iman Haywood, fashion model,
while filming *The Human Factor*,
directed by Otto Preminger, 1979

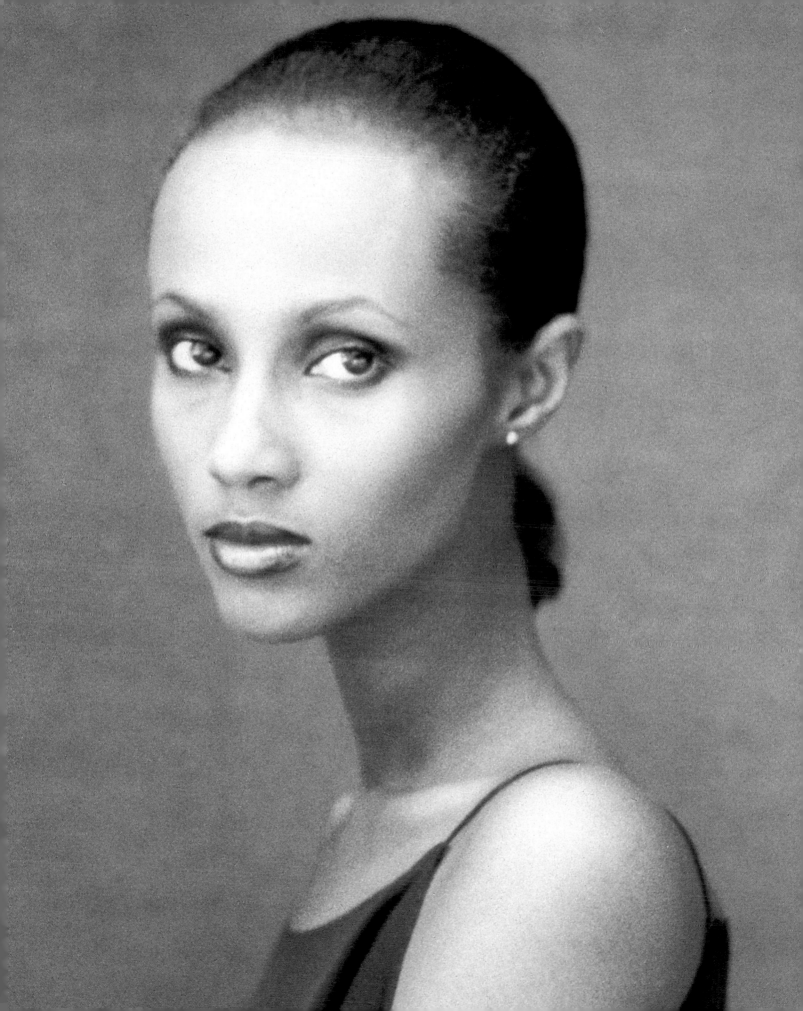

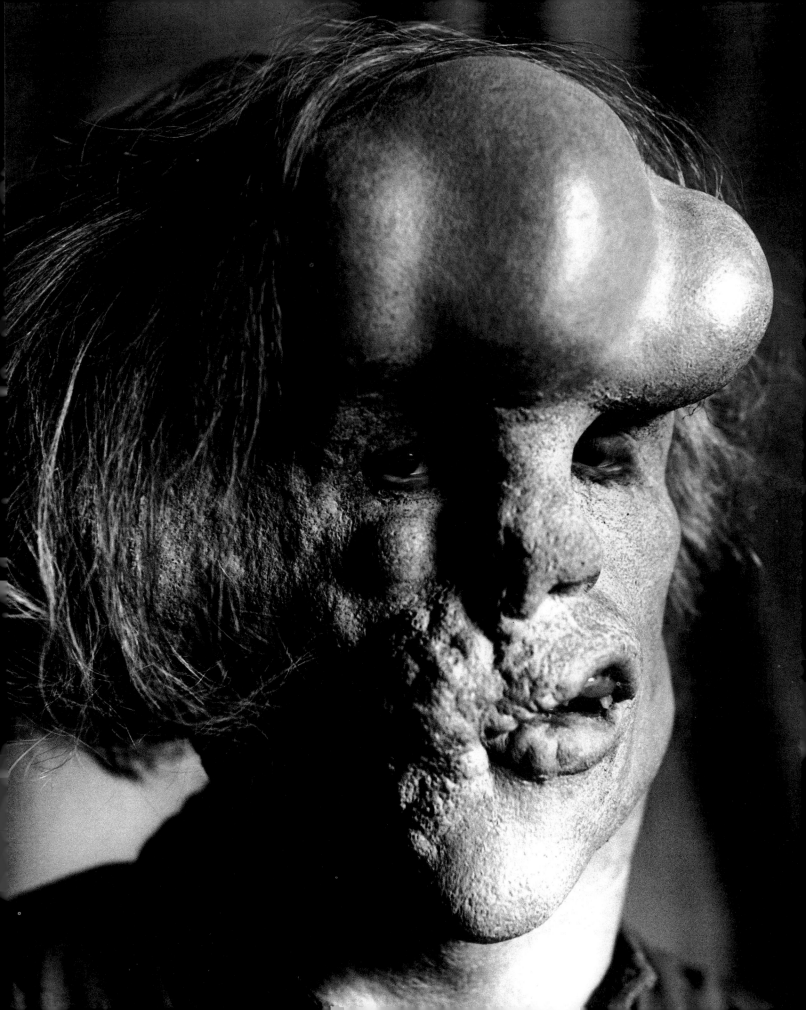

John Hurt and (*opposite*) as 'The Elephant Man,'
directed by David Lynch, 1981

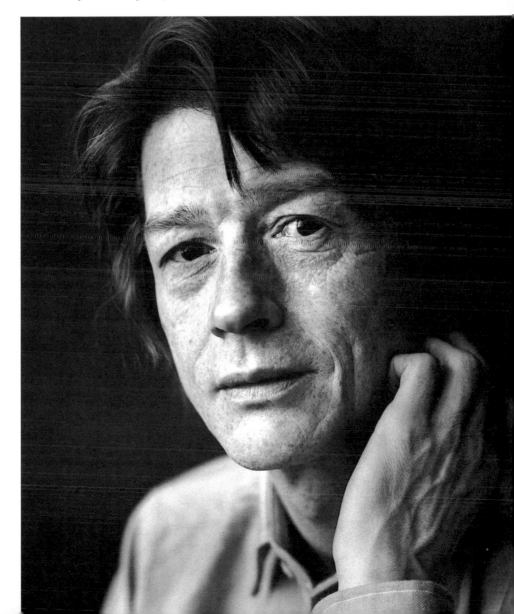

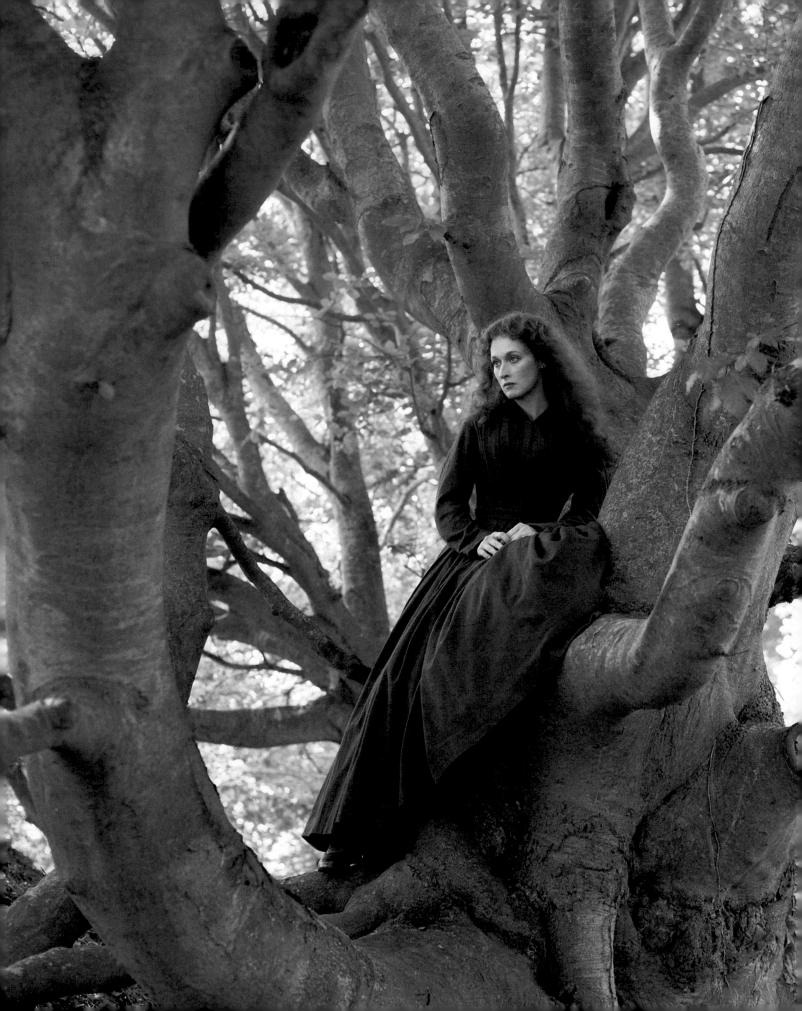

Meryl Streep during filming for
The French Lieutenant's Woman in 1980.
In 1983 she won the Oscar for Best Actress
for her performance in *Sophie's Choice*

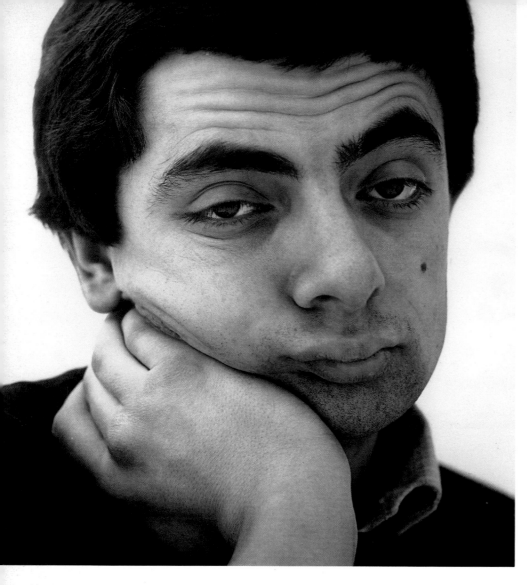

Rowan Atkinson, satirical actor in the
BBC's *Not the Nine O'Clock News*, 1981

Rik Mayall, comedian;
he created Kevin Turvey
and *The Young Ones* for BBC TV, 1983

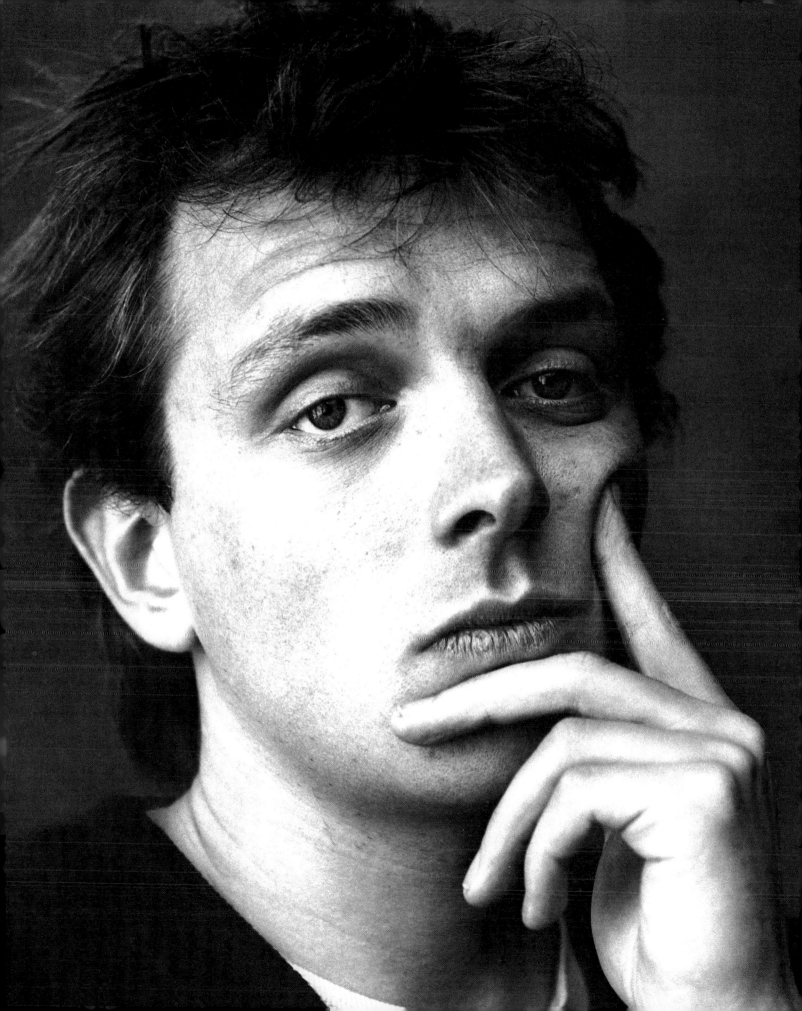

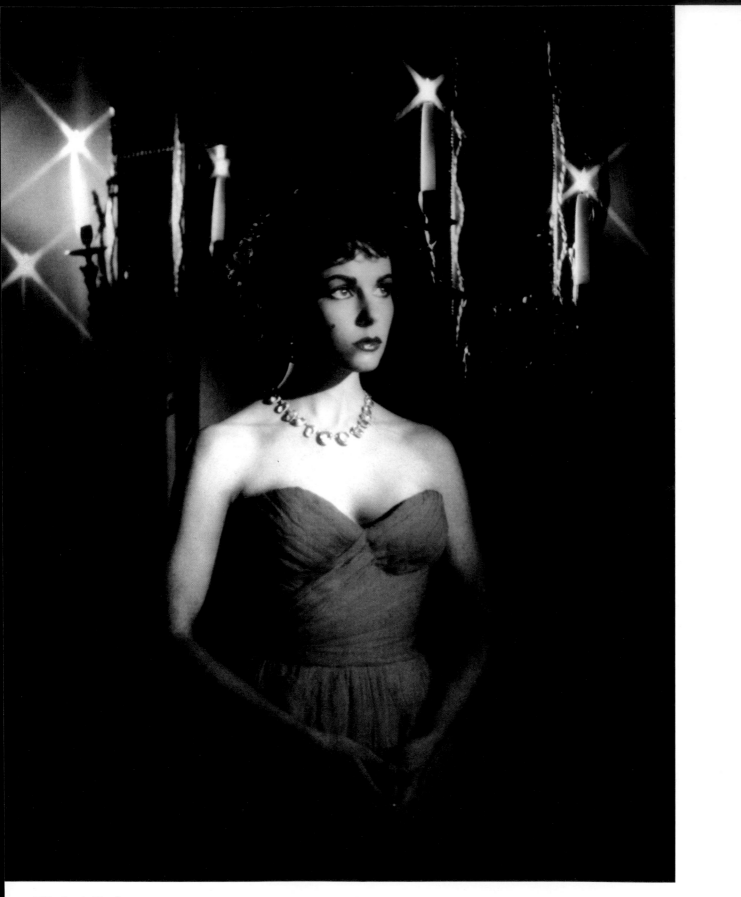

Elizabeth Taylor . . .

Marilyn Monroe . . .

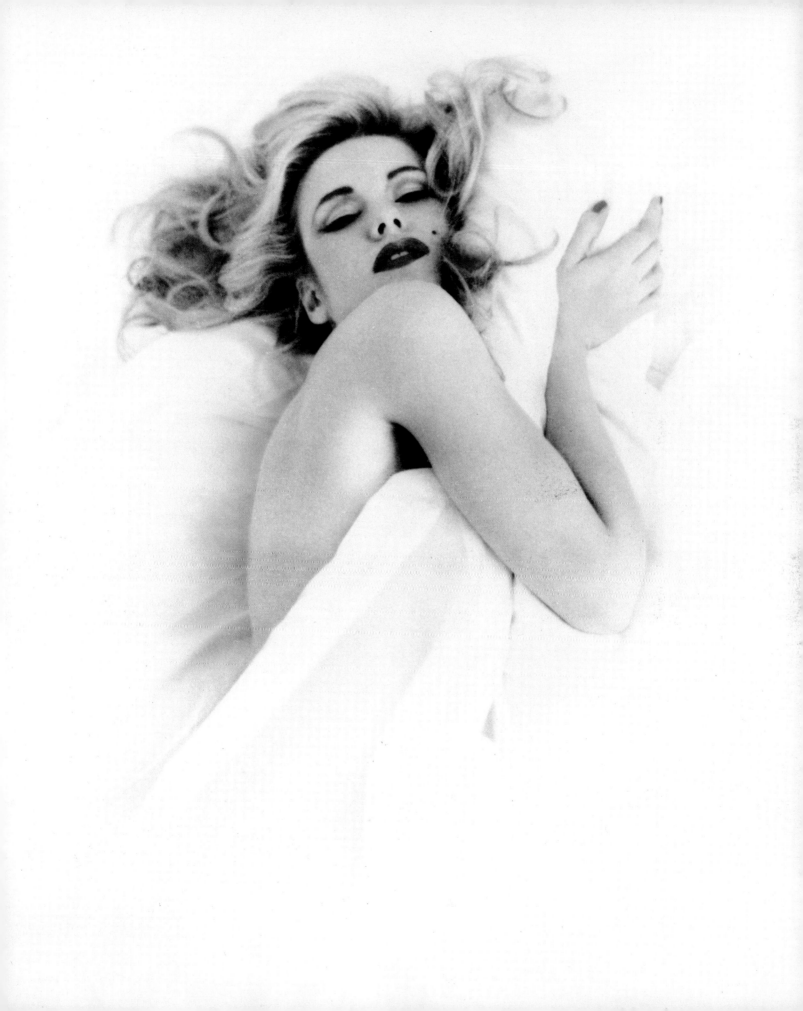

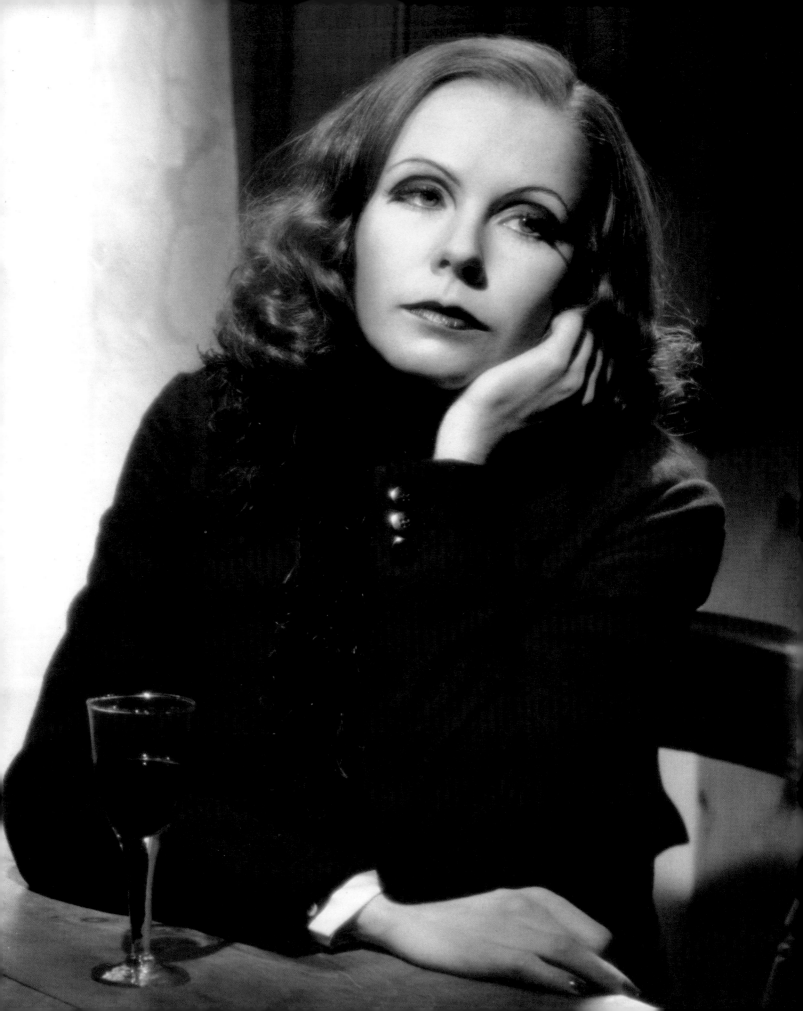

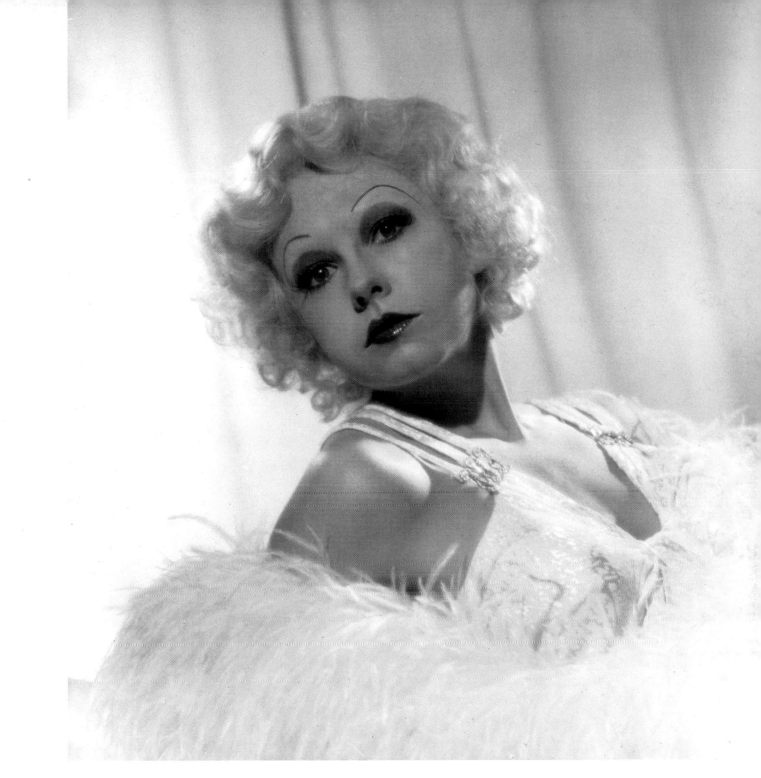

Jean Harlow . . .

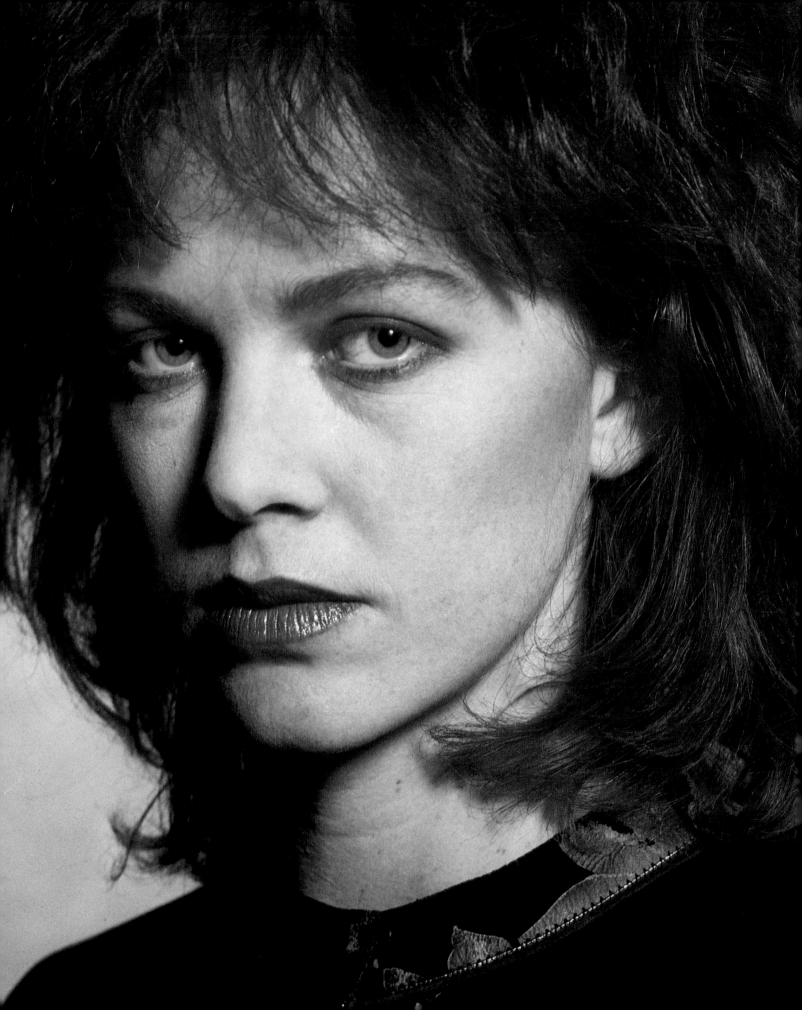

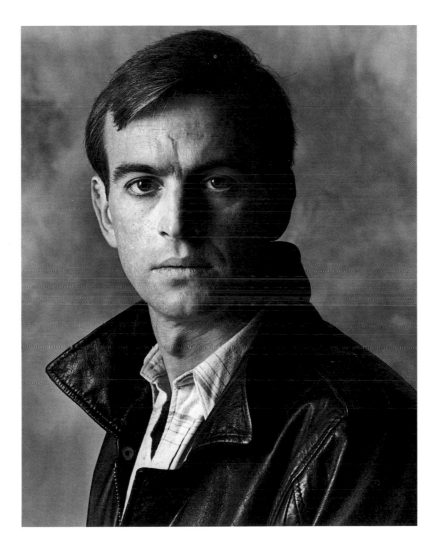

Ian Charleston, actor;
he played Eric Liddel in *Chariots of Fire*, 1981

Judy Davis, Australian actress;
star of *My Brilliant Career* 1979 and *Who Dares Wins* 1982

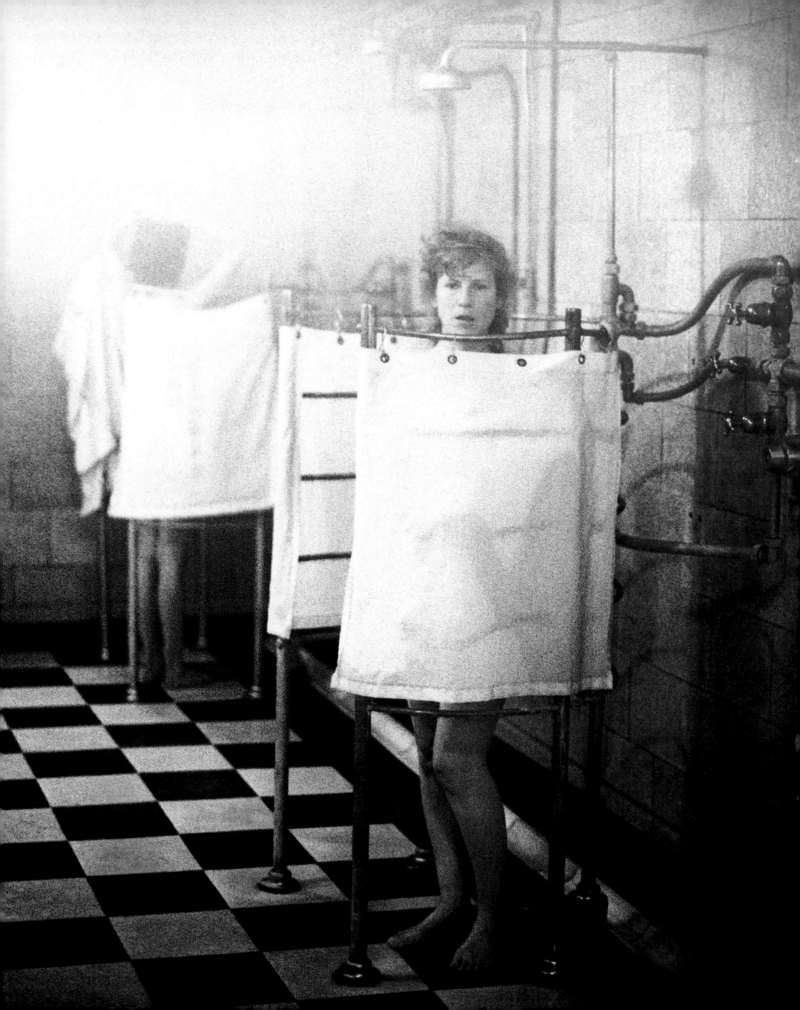

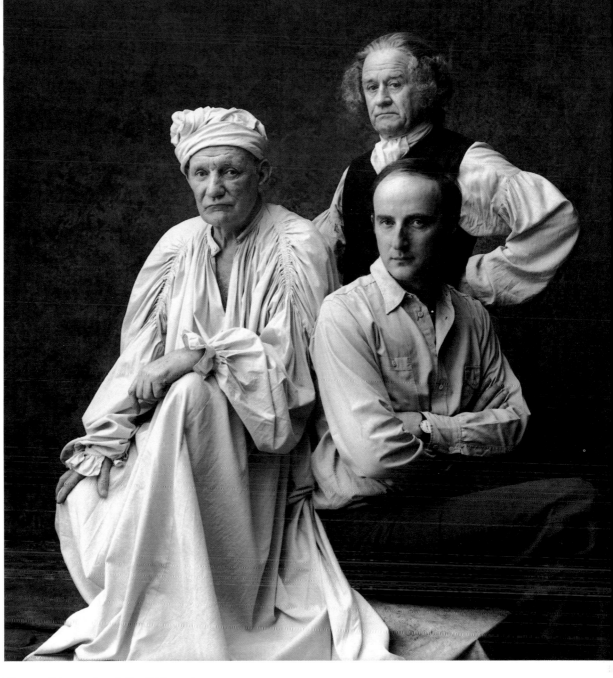

Trevor Howard and Cyril Cusack
in costume for *No Country for Old Men* 1981,
with director Tristram Powell

Nell Dunn in the Porchester Hall
Turkish Baths at the time of the
opening of her play, *Steaming* 1981

Lindsay Anderson, actor, writer,
film and theatre director;
he directed *Britannia Hospital* 1982

Barry Humphries,
alias Dame Edna Everage

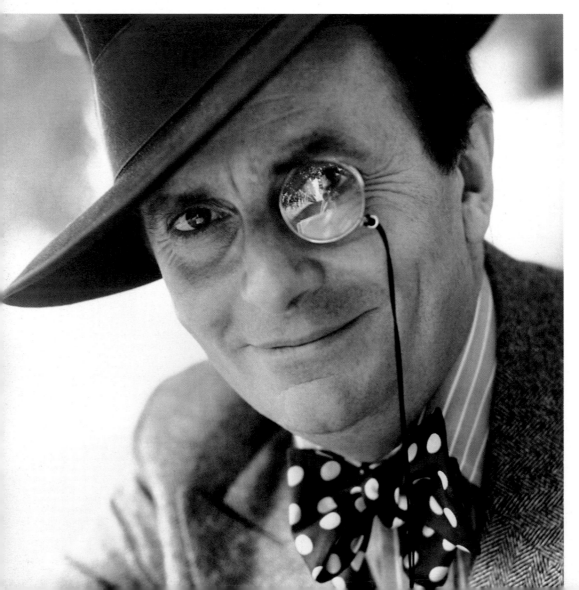

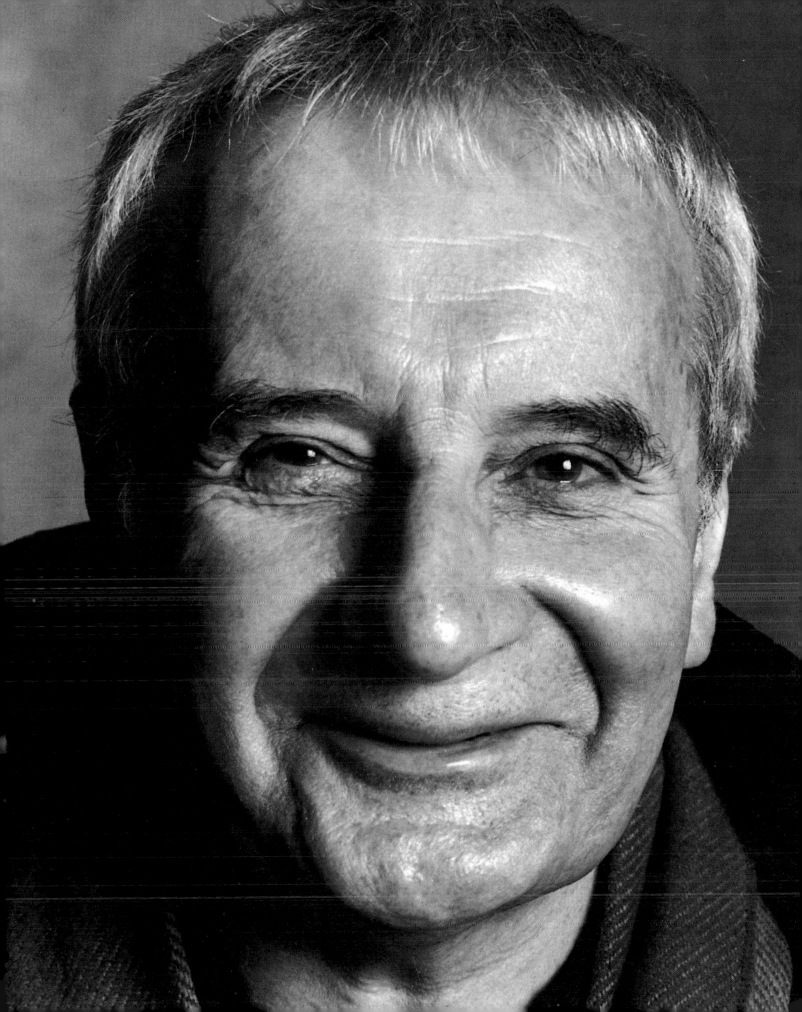

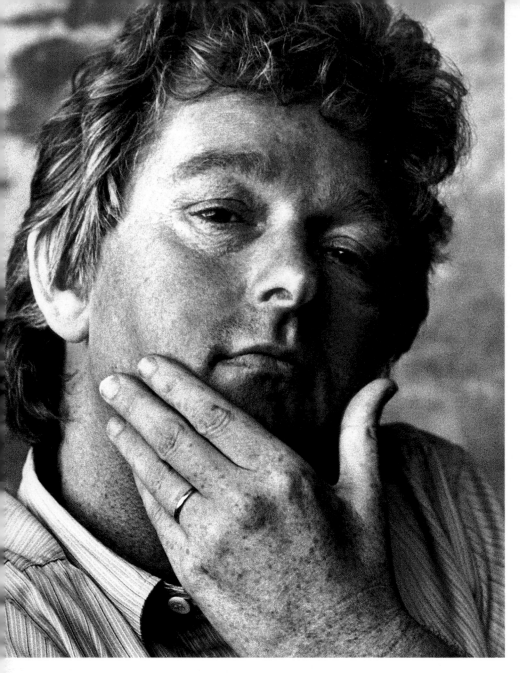

Hugh Hudson, director of *Chariots of Fire*,
which won the Oscar for Best Picture in 1982

David Puttnam, producer of
Chariots of Fire 1981, and of *Local Hero* 1983

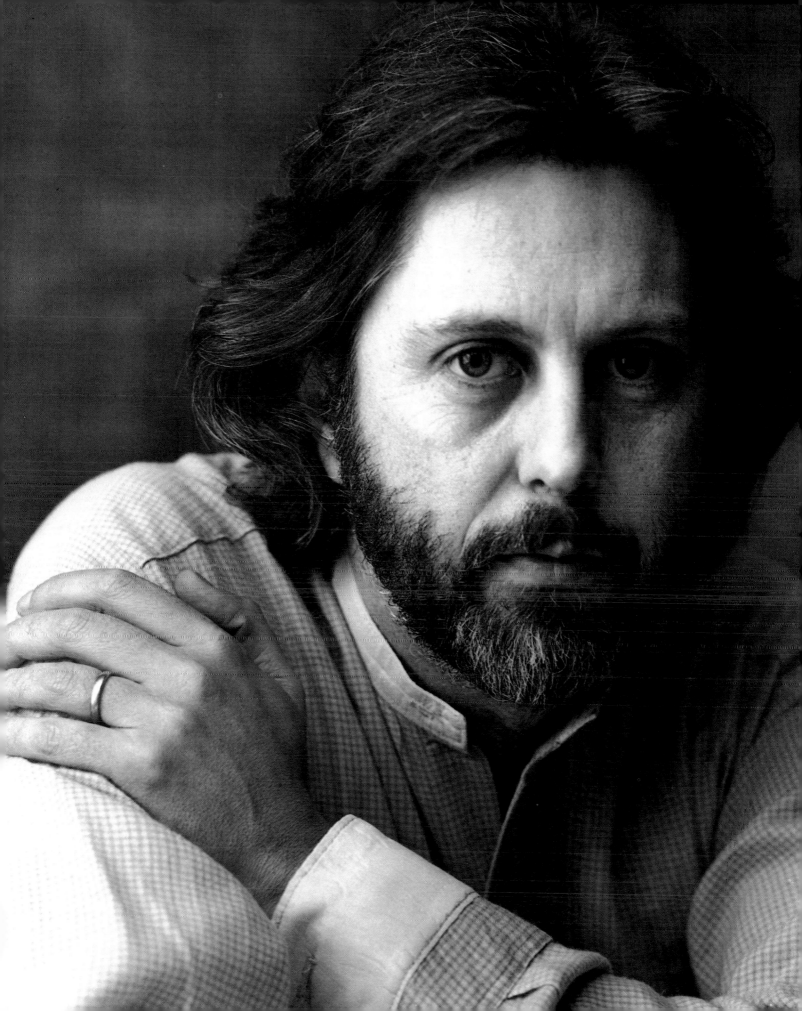

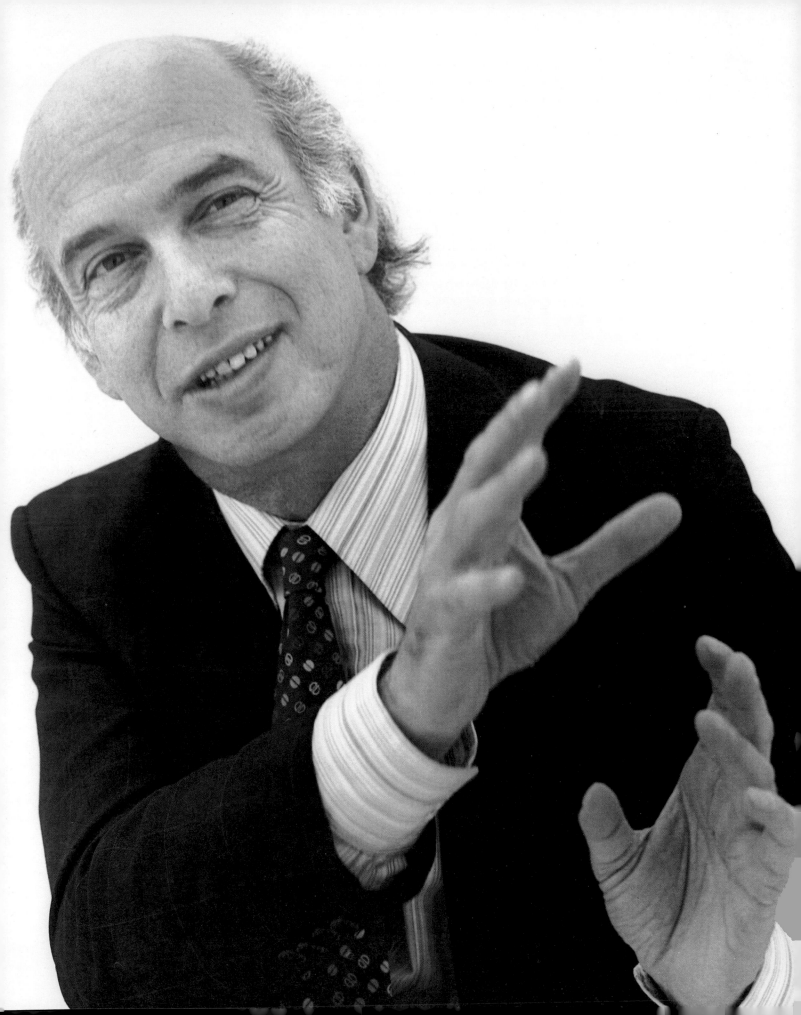

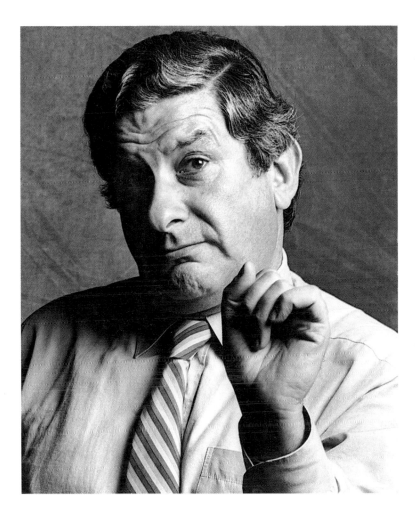

Jeremy Isaacs,
first Chief Executive of Channel Four Television, 1982

Sir Claus Moser,
Chairman of the Royal Opera House, Covent Garden, 1980

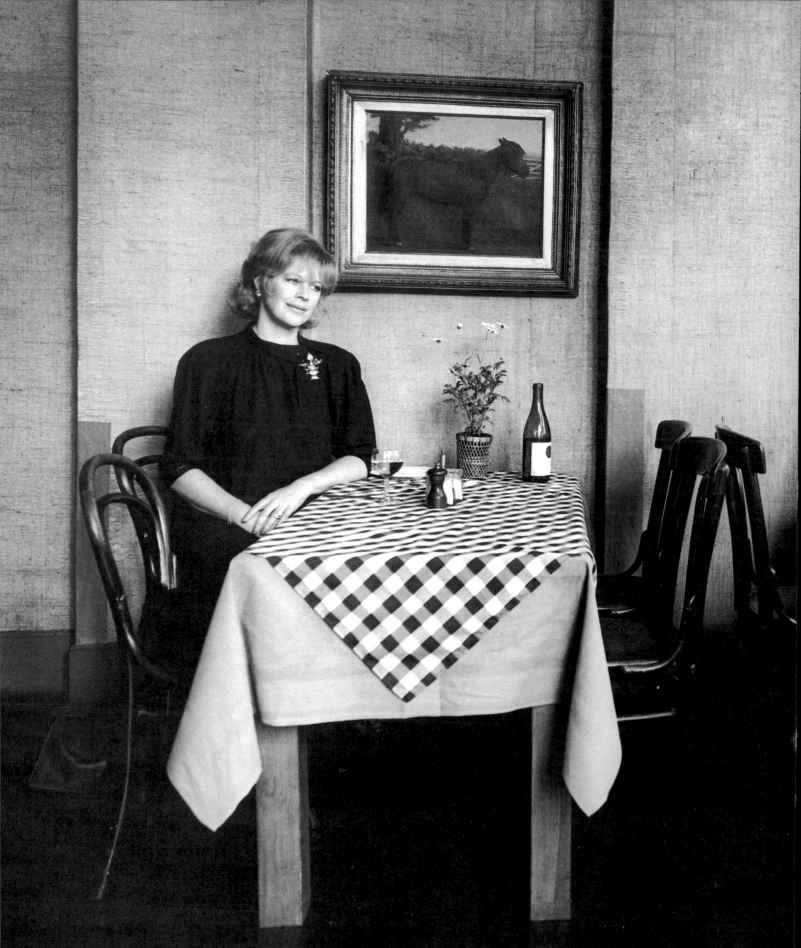

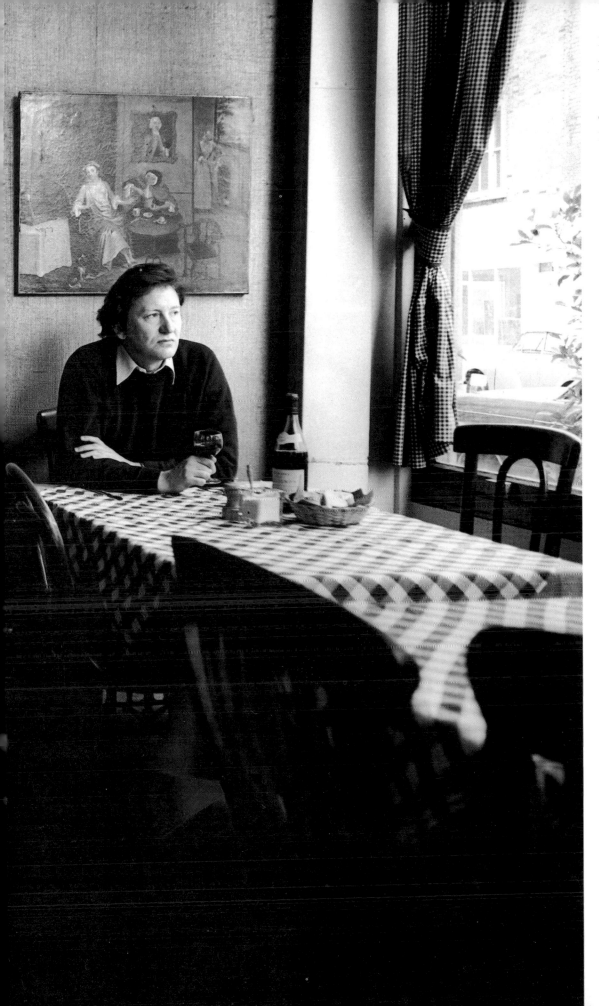

Lady Antonia Fraser and
Michael Holroyd,
biographers and past
Chairmen of the
Society of Authors, in
Thompson's restaurant,
London, 1980

Bruce Chatwin, traveller and writer of
In Patagonia 1977, *The Viceroy of Ouidah* 1982
and *On the Black Hill* 1982

Charles MacLean; his last novel,
The Watcher, was published in 1983

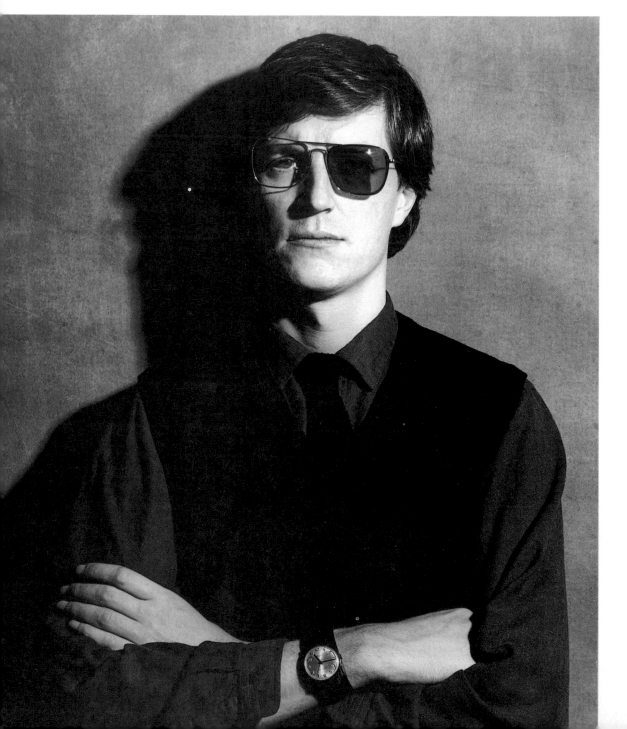

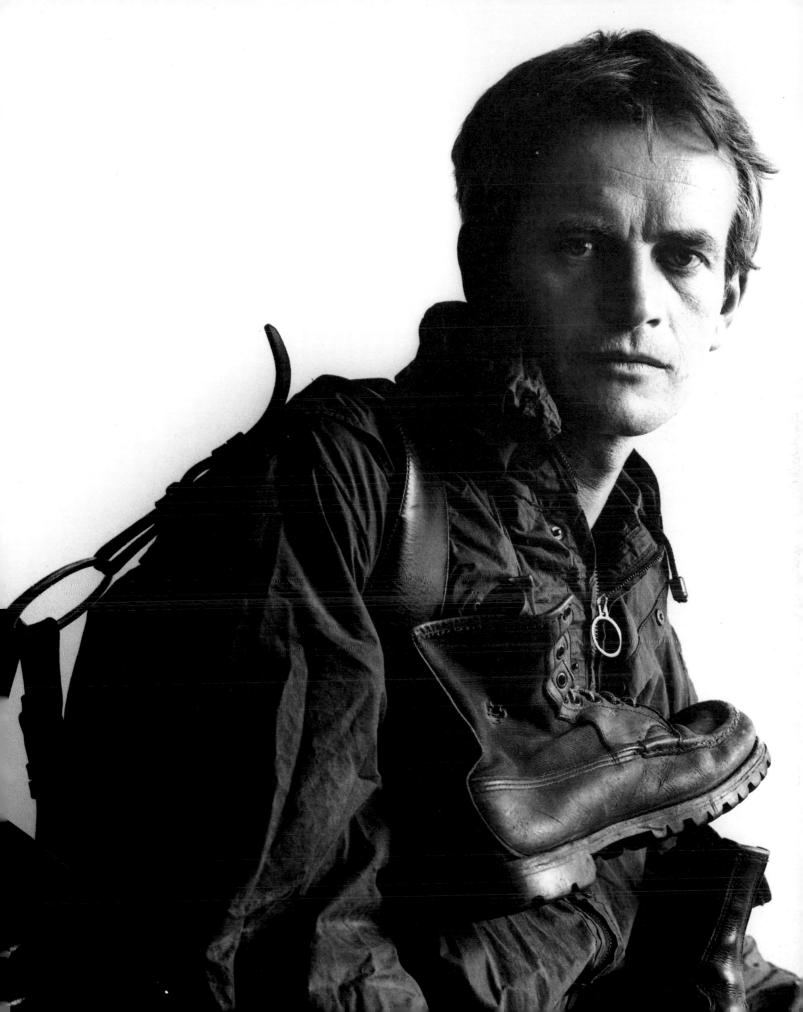

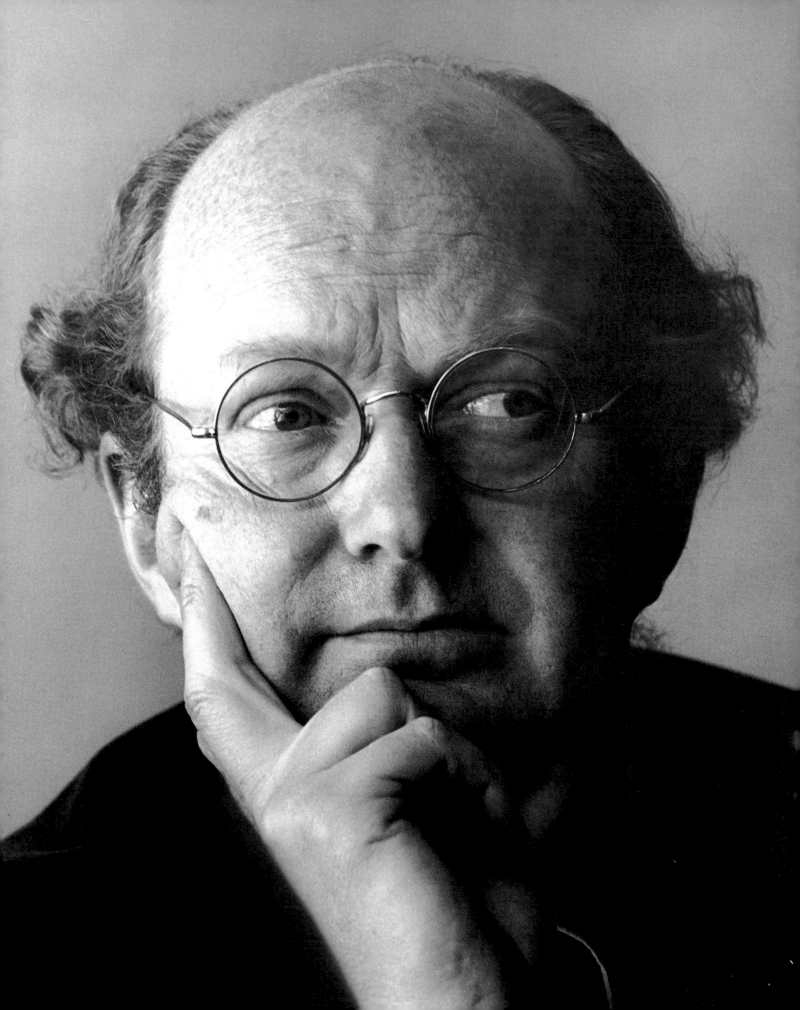

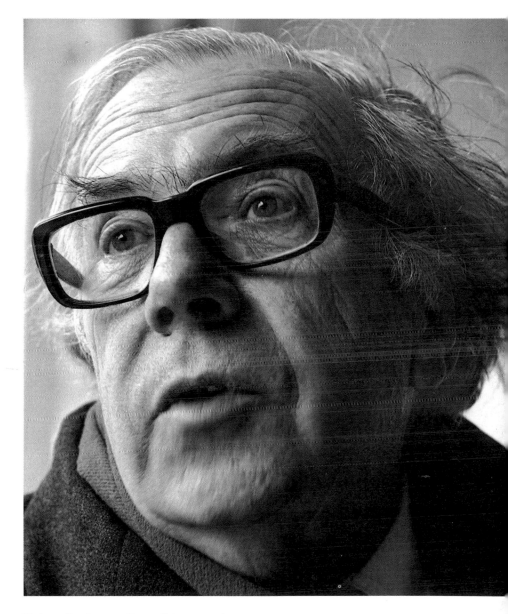

Robert Latham, editor of the complete
Diaries of Samual Pepys, 1983

Auberon Waugh, journalist, satirist,
diarist for *Private Eye*, 1983

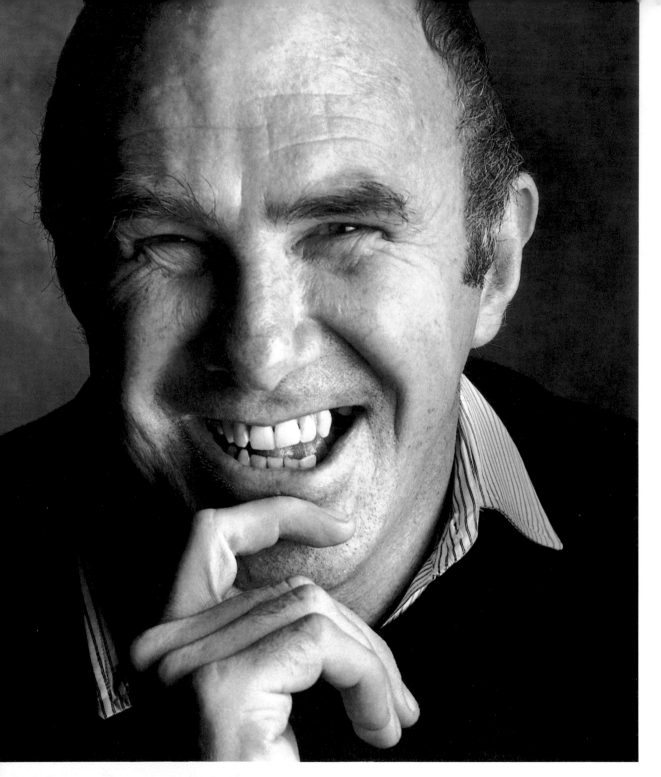

Clive James, writer, broadcaster and
humorist whose autobiographical
Unreliable Memoirs was published in 1980

Anthony Burgess, critic and novelist;
his recent books include
Earthly Powers 1980 and
The End of the World News 1983

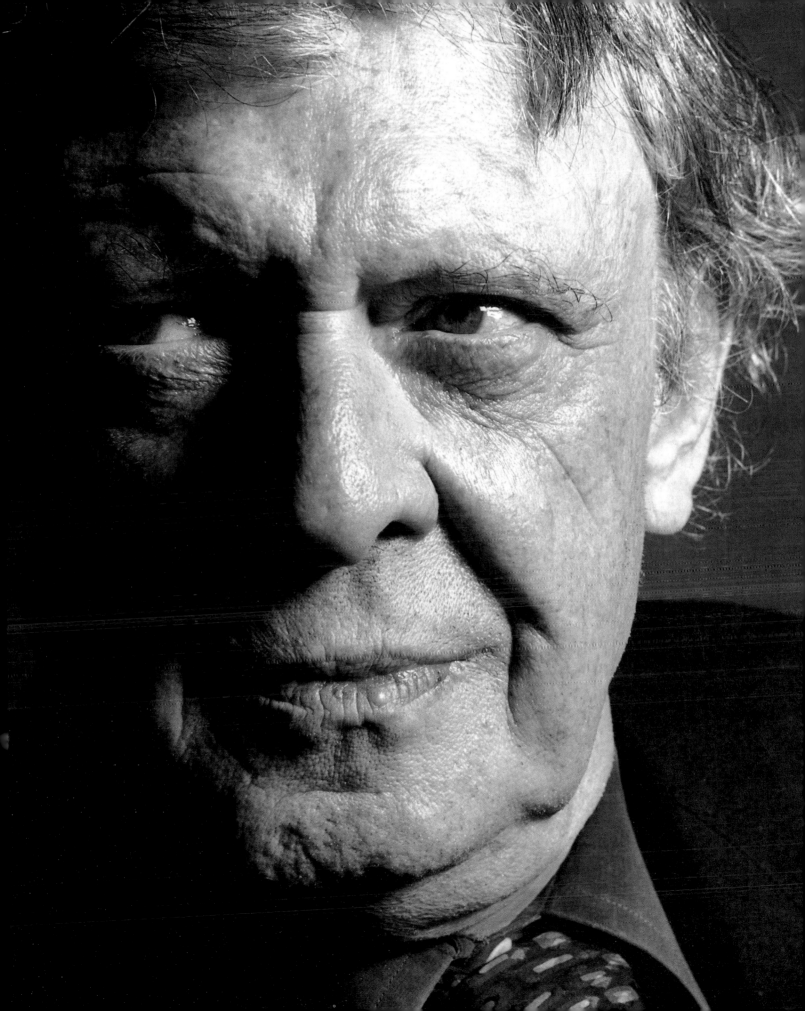

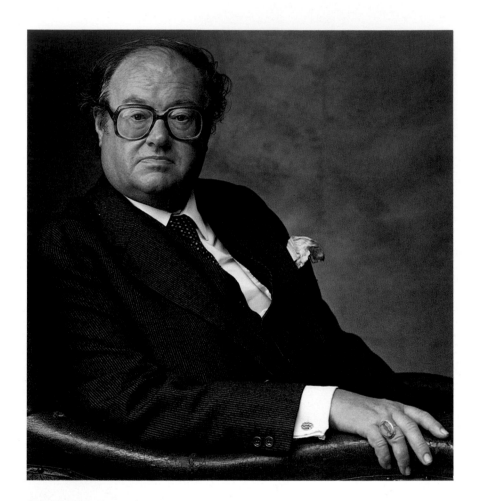

John Mortimer, Q.C.,
playwright,
journalist and critic;
in 1982 his play,
A Voyage Round My Father
was televised
and his autobiography,
Clinging to the Wreckage, published.
1983 sees a new *Rumpole* television series
and a new *Rumpole* book

Marina Warner, writer and critic;
author of *Alone of All her Sex : the
Myth and Cult of the Virgin Mary*, 1976;
her second novel was *The Skating Party* 1982

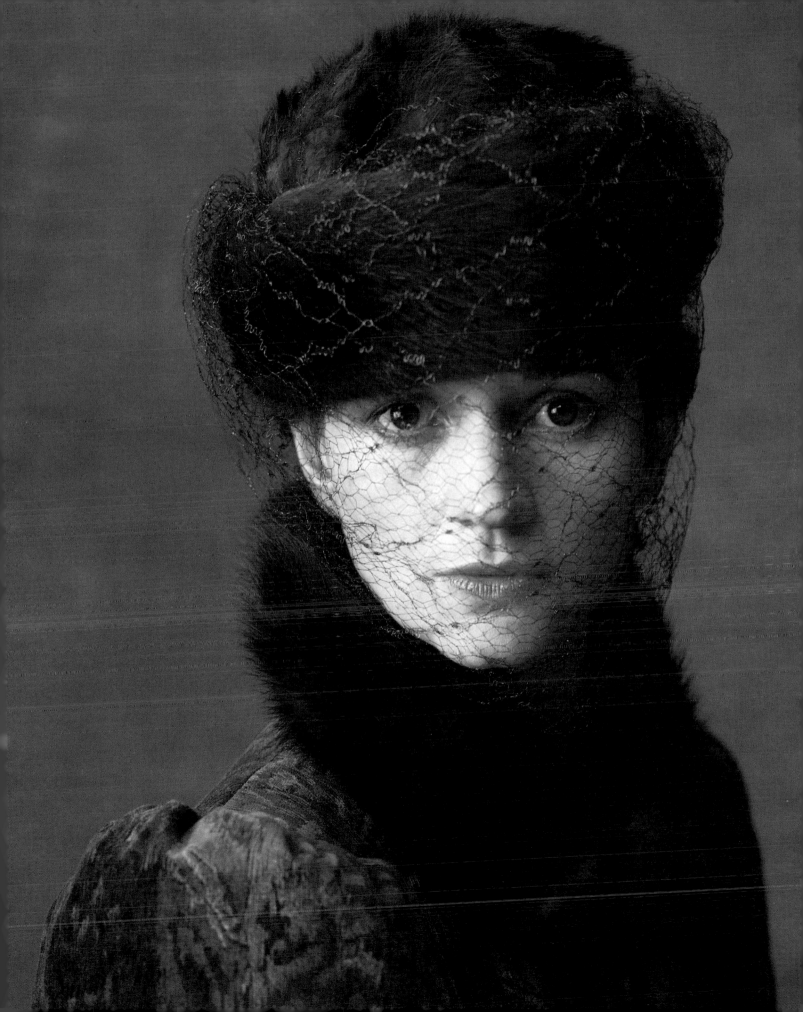

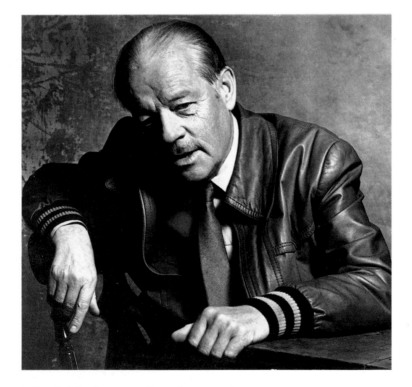

Alistair MacLean, author of twenty six novels,
including *Floodgate* 1983

Iris Murdoch, Fellow of St Anne's College, Oxford;
philosopher, playwright and novelist;
The Philosopher's Pupil
was published in 1983

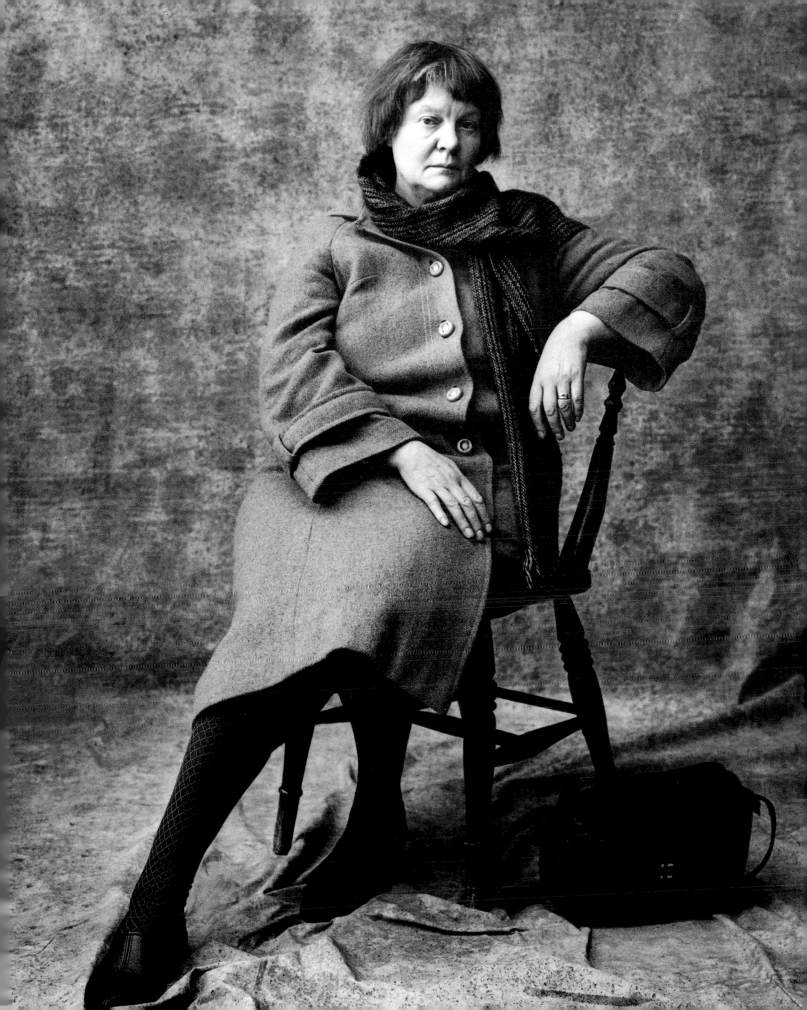

Tom Sharpe, novelist;
his last book was *Vintage Stuff* 1983

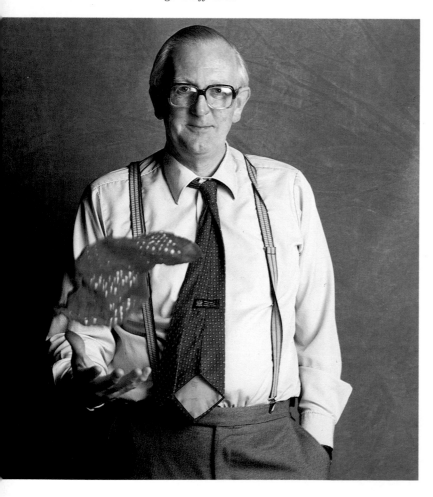

V. S. Naipaul, author;
his recent books include
A Bend in the River 1979
and *Among the Believers* 1981

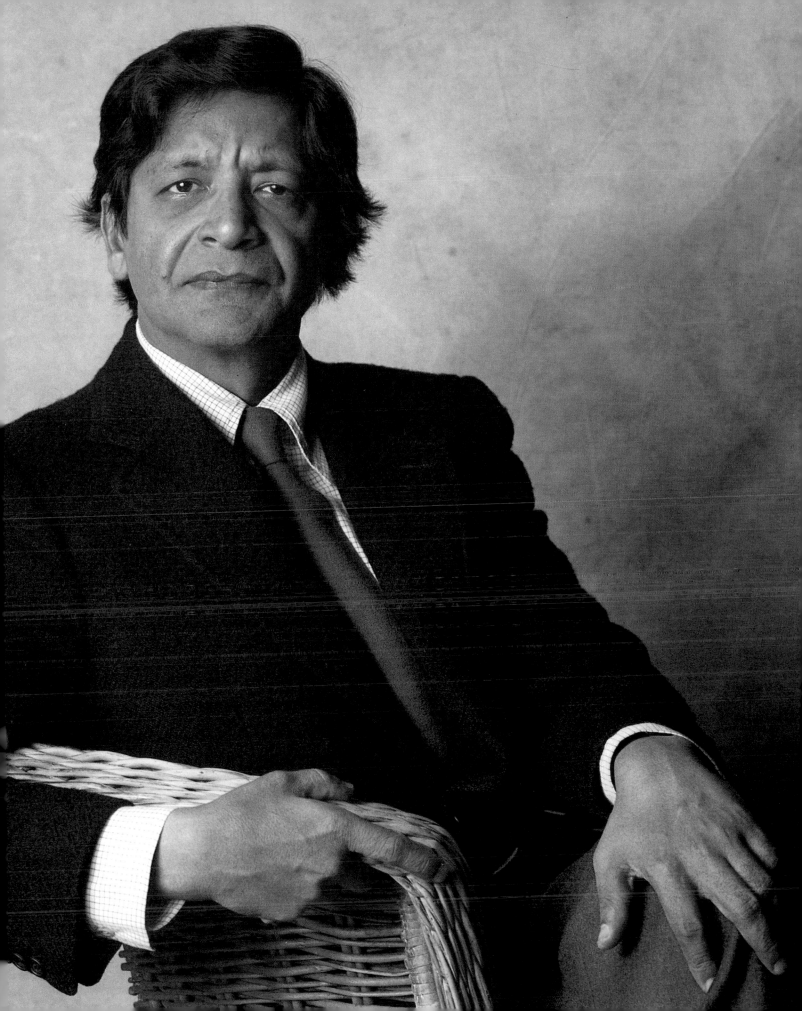

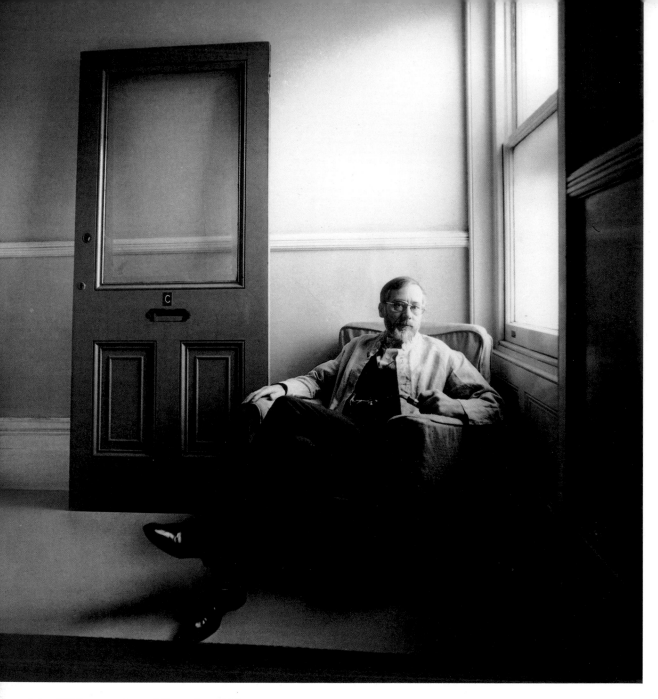

Alan Sillitoe, author of *Saturday Night
and Sunday Morning* 1958 and *The Loneliness of the
Long Distance Runner* 1959

Anthony Powell, author of
the 12-volume sequence,
A Dance to the Music of Time 1951–1975,
and *O How the Wheel Becomes It!* 1983

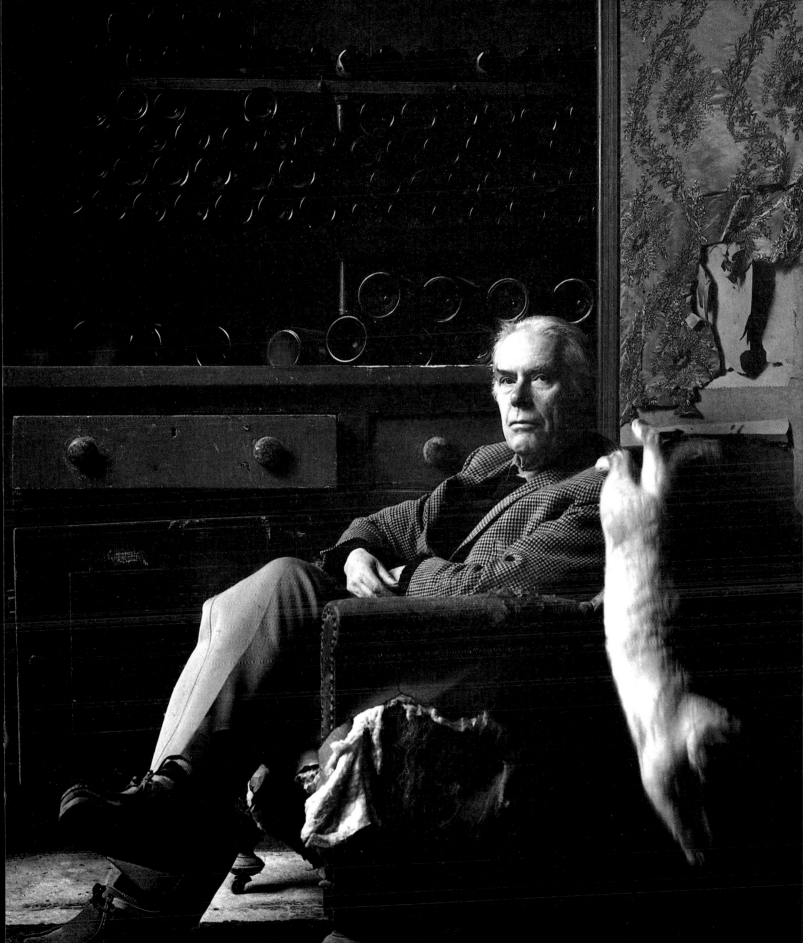

Gilbert and George,
eccentric 'living' sculptures
in their 18th century house
in Spitalfields, London, 1981

John Davies,
figurative sculptor, 1981

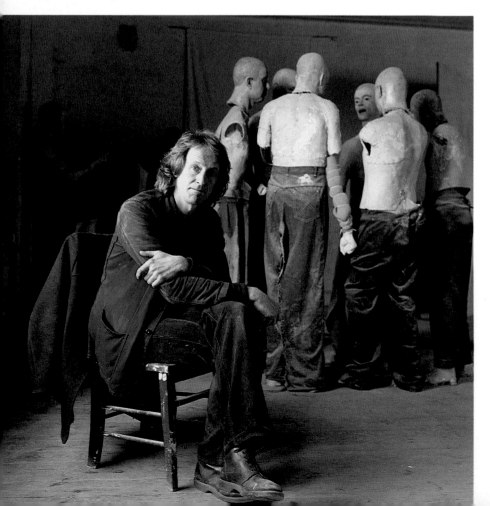

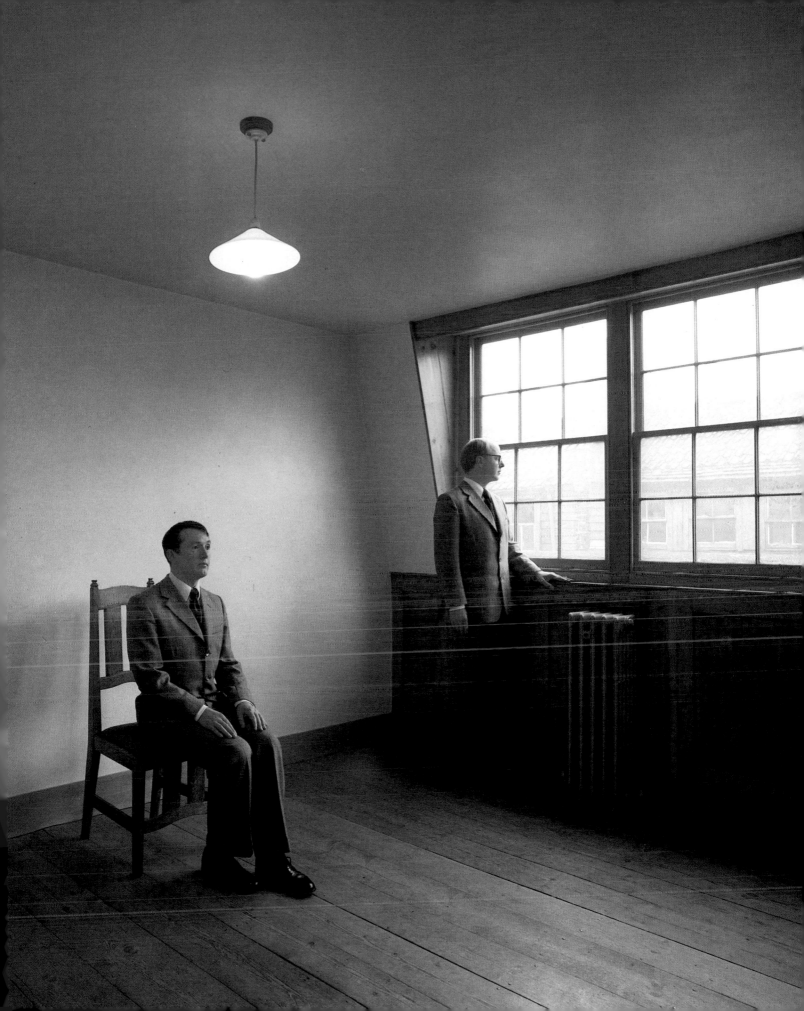

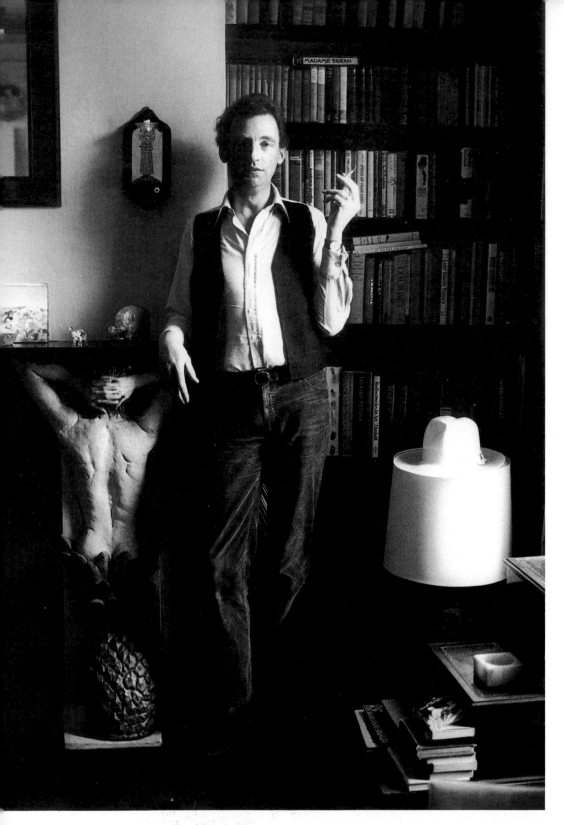

Patrick Procktor, watercolorist,
portrait painter, print maker and wit, 1979

Barry Flanagan whose bronze hare
sculptures represented Britain at the
Venice Biennale 1982

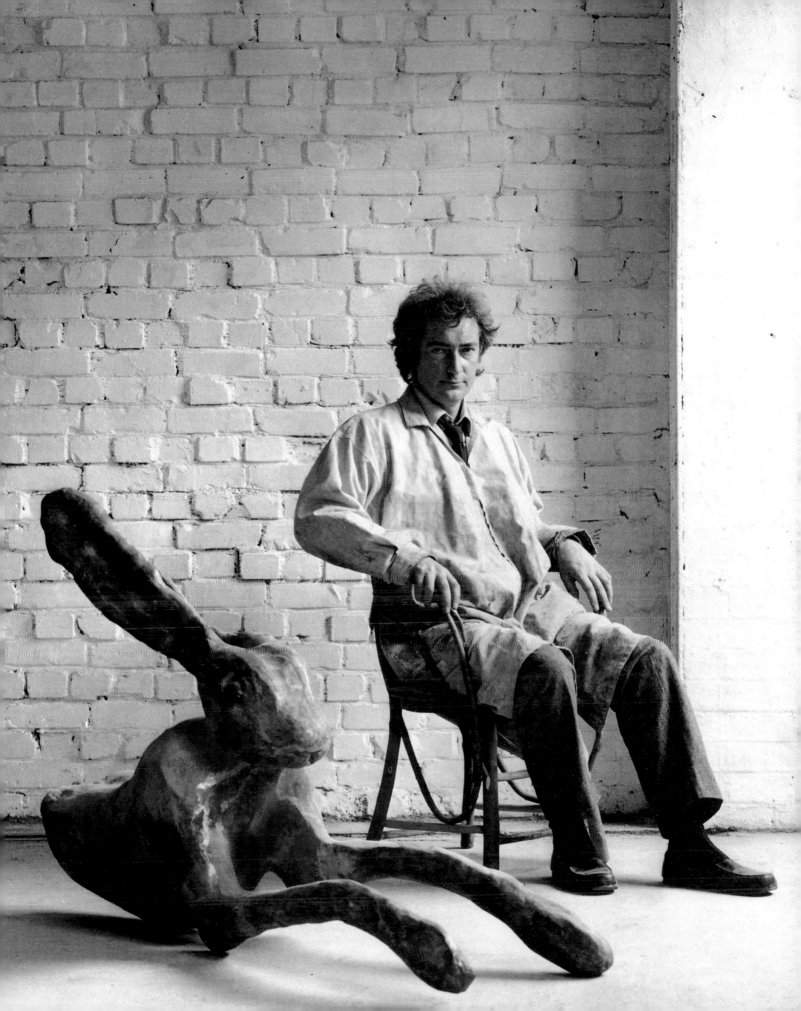

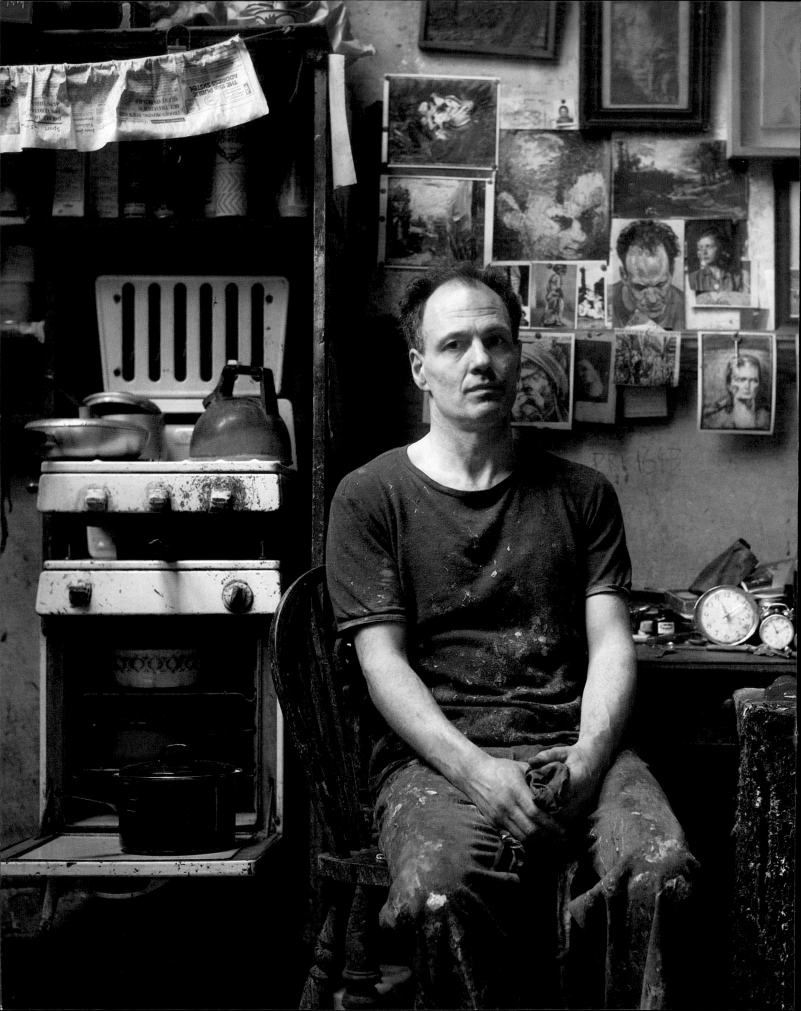

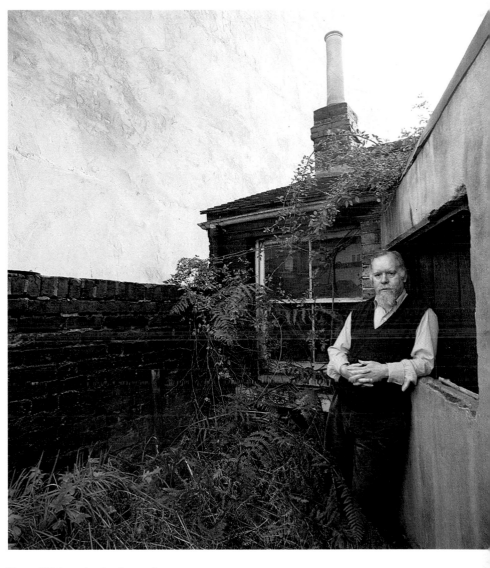

Peter Blake who had a major
retrospective at the Tate Gallery in 1982

Frank Auerbach in his studio, 1982

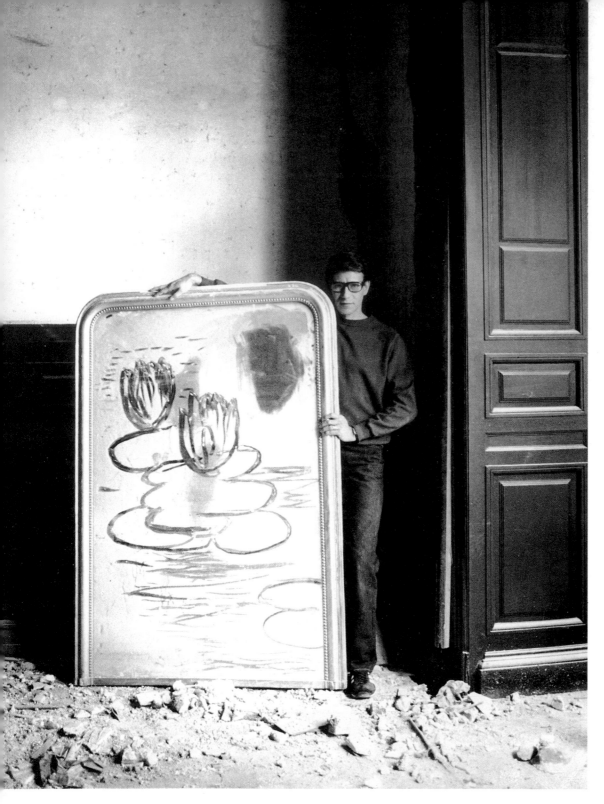

Yves Saint Laurent in his unfinished
house outside Deauville, 1980. He drew
water lilies in the dust on a looking glass

Sir Hugh Casson, architect,
President of the Royal Academy and
Provost of the Royal College of Art.
He drew his favourite building,
the Albert Memorial, and crossed out
a drawing of his least favourite
modern building

96

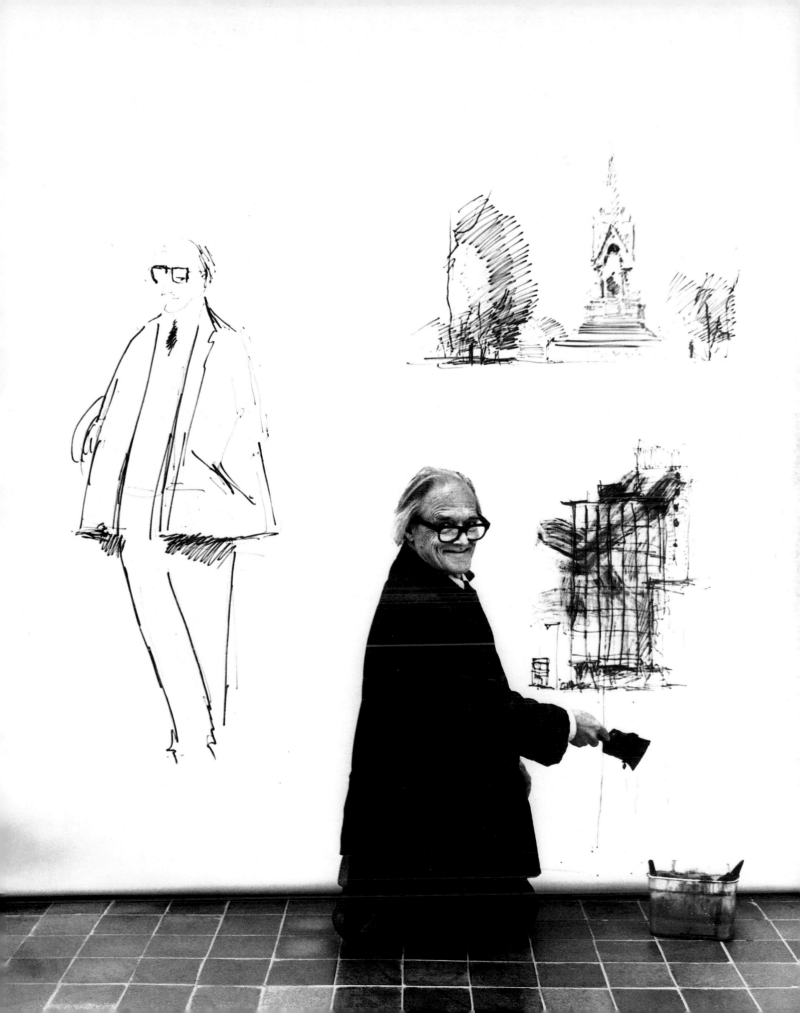

Carl Toms, theatre designer; he designed
the interior of the newly restored
Theatre Royal in Bath in 1982 and
Tom Stoppard's play,
The Real Thing 1982

Sir Sidney Nolan, Australian painter,
in front of a backdrop for Saint-Saën's
opera, *Samson et Dalila*, for the Royal
Opera House, Covent Garden, 1981

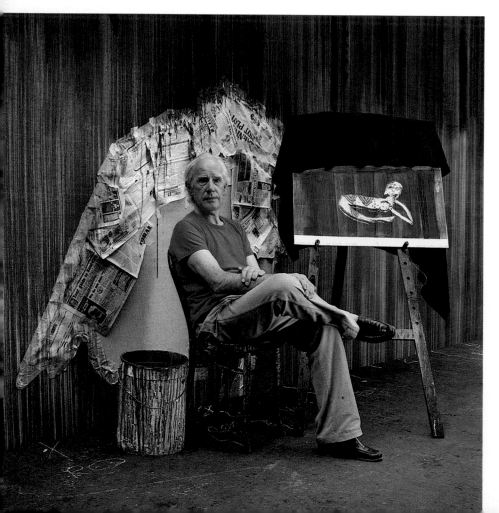

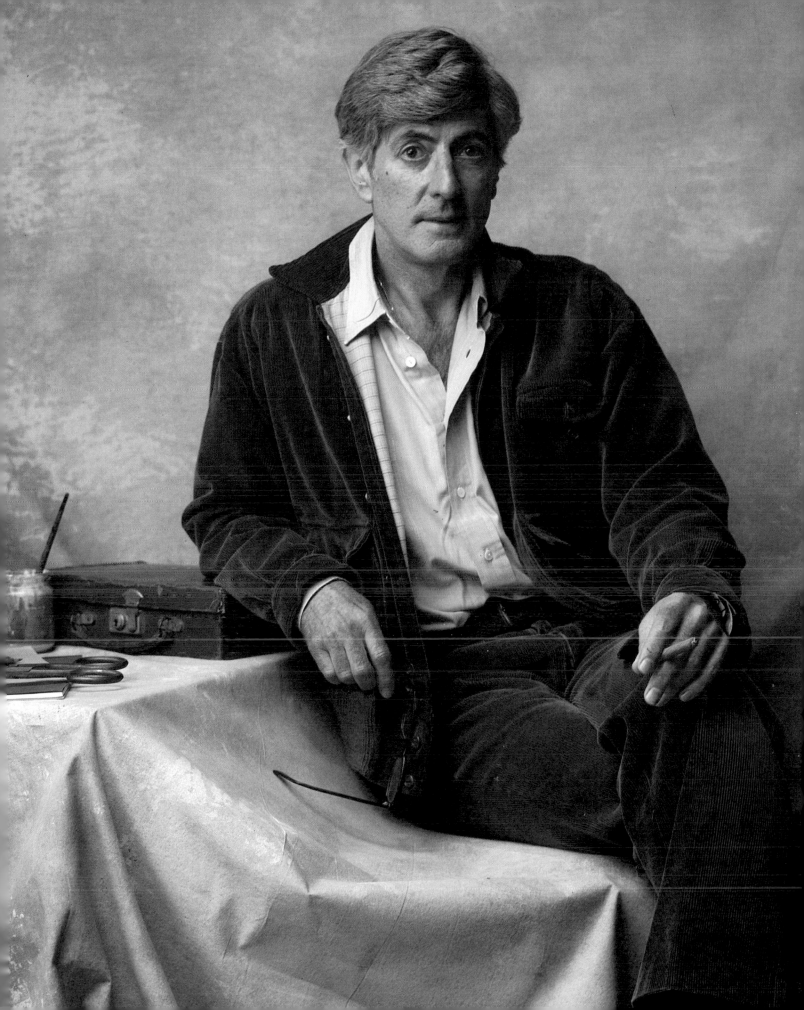

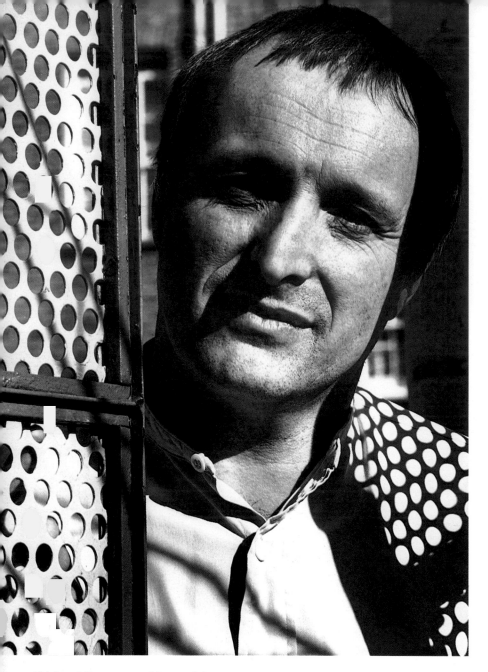

Richard Rogers, architect of the
Centre Pompidou and the new
Lloyds of London building, 1980

Sir Alec Issigonis, designer of the
Morris Minor and the Mini, 1979

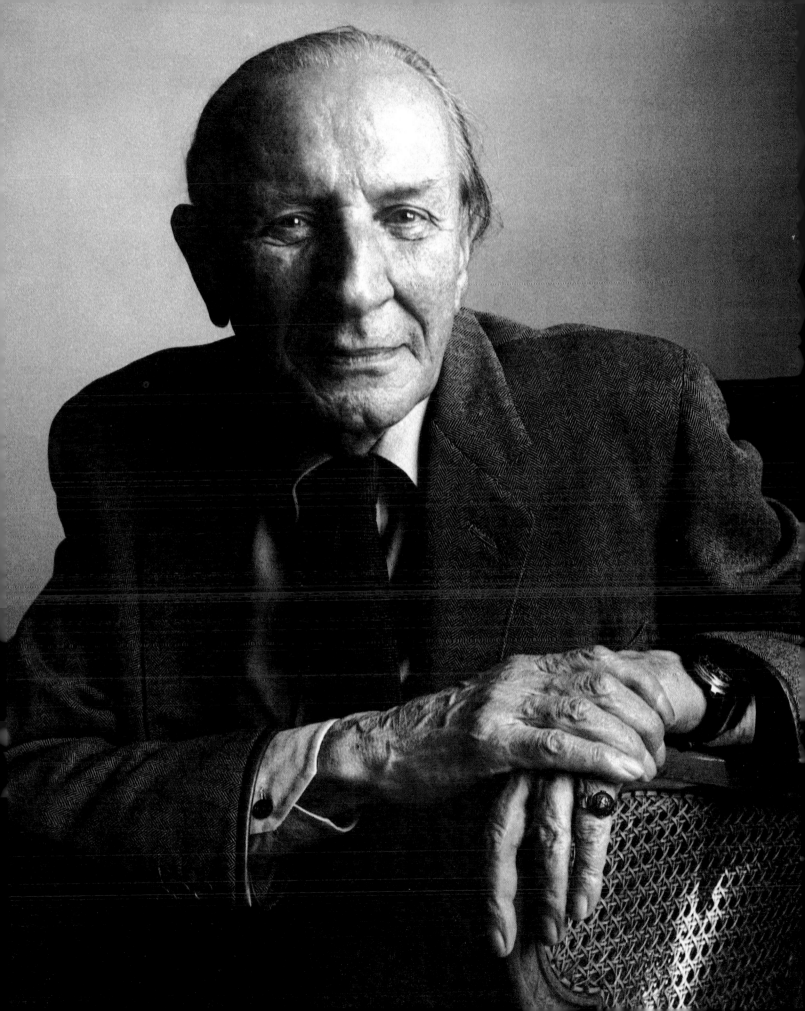

Olivier as King Lear directed by
Michael Elliott for Granada
Television 1983

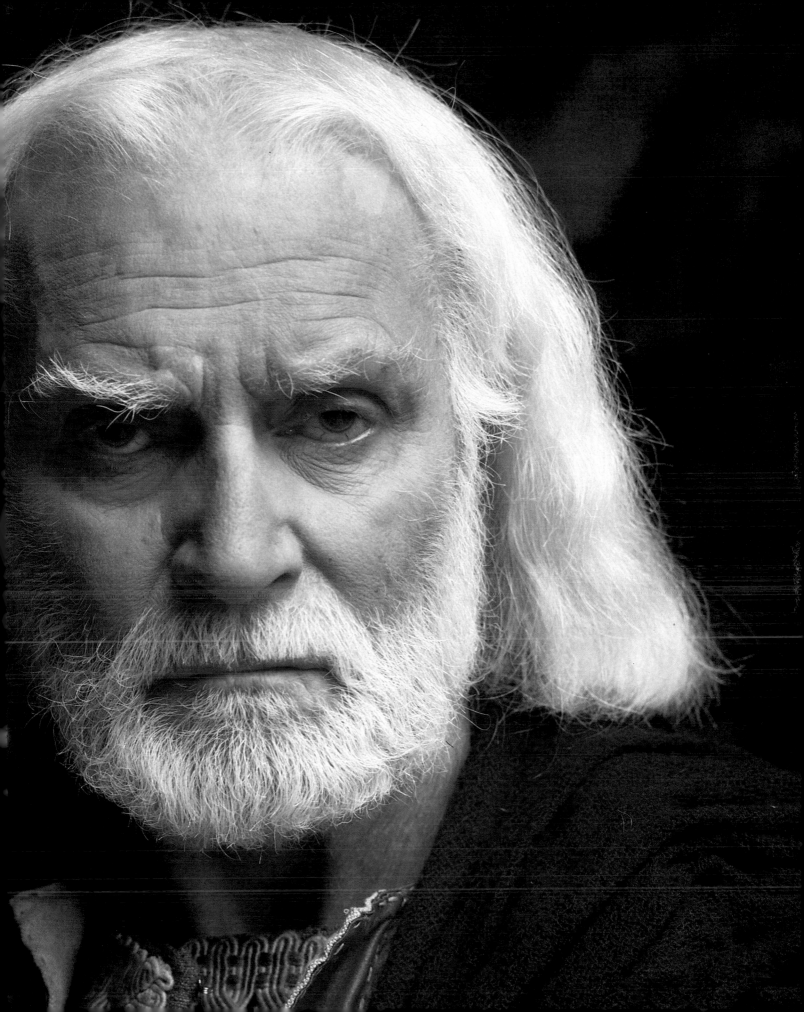

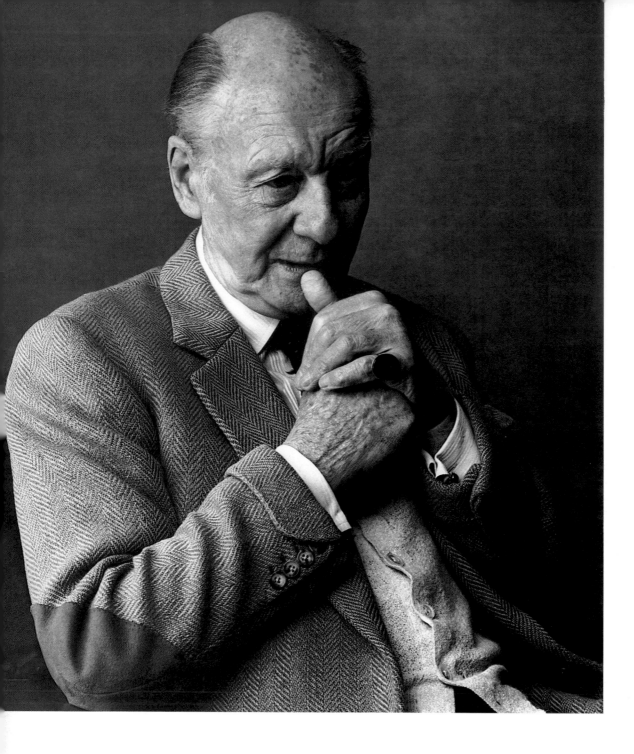

Sir John Gielgud (*above*) and Sir Ralph Richardson (*right*)
made their first stage appearances in 1921.
In 1981 Sir John was playing Edward Ryder in
Brideshead Revisited, while Sir Ralph was
touring North America in the National Theatre's
production of *Early Days*

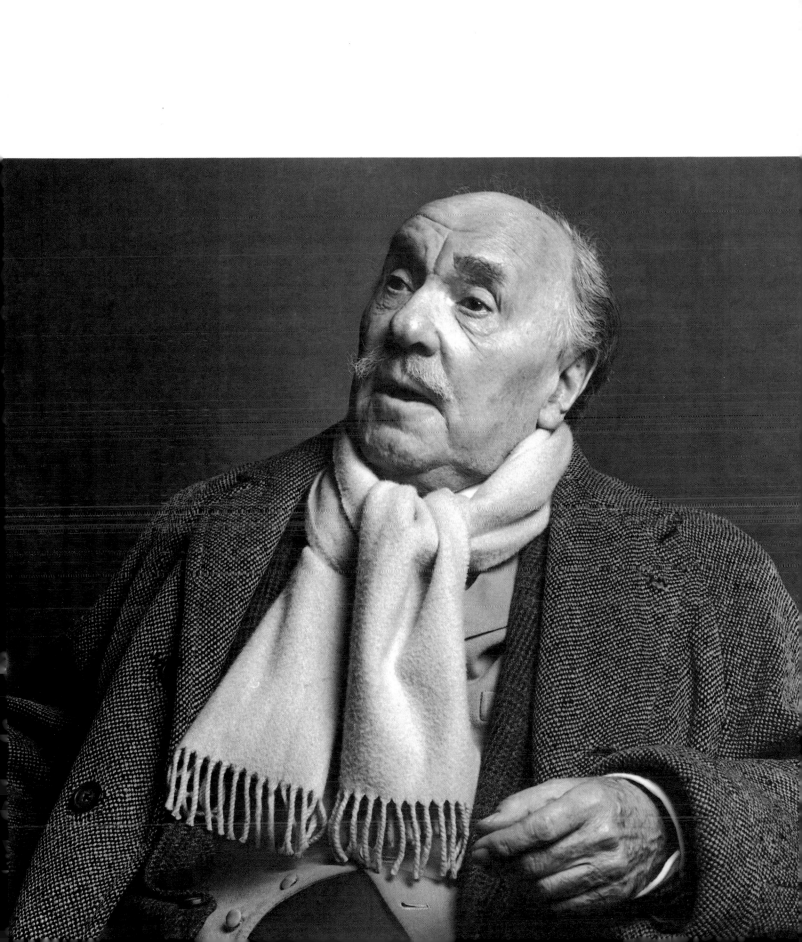

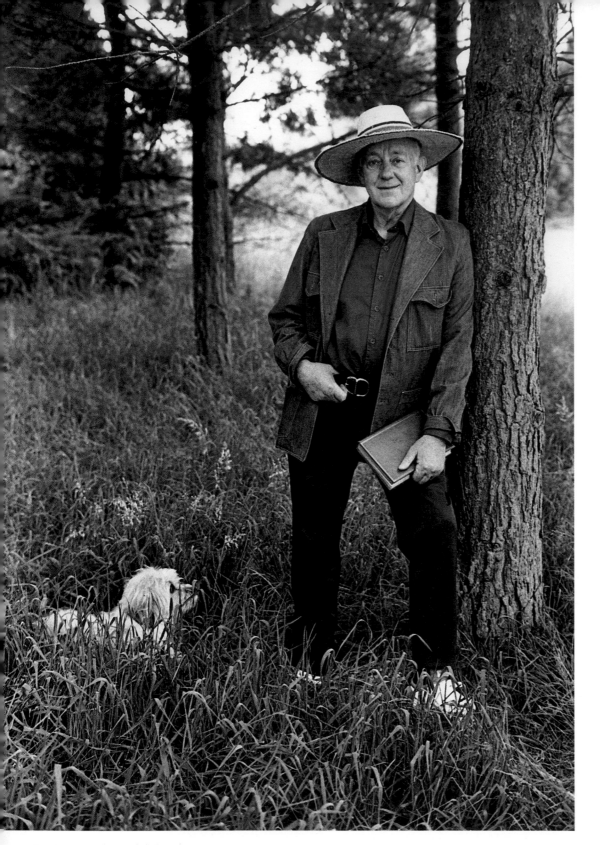

Sir Alec Guinness playing Smiley in
Tinker, Tailor, Soldier, Spy for
BBC TV, for which he won a British
Academy award in 1980

Dame Peggy Ashcroft as the Countess
in the Royal Shakespeare Company's
production *All's Well that Ends Well* 1982

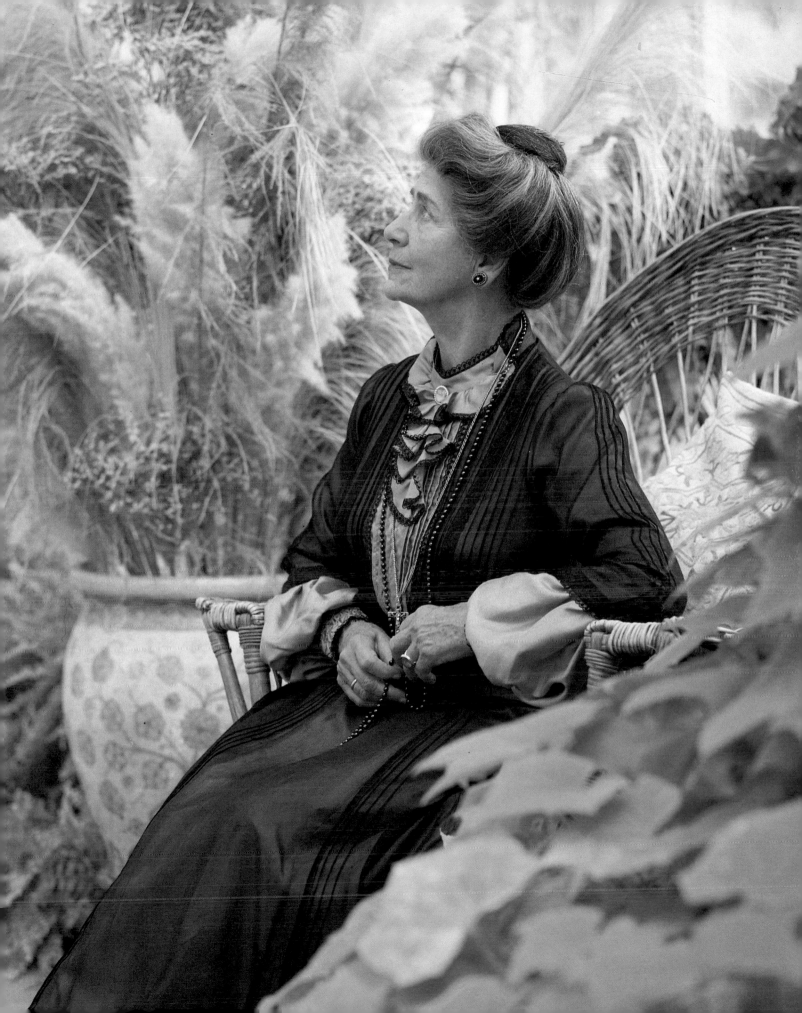

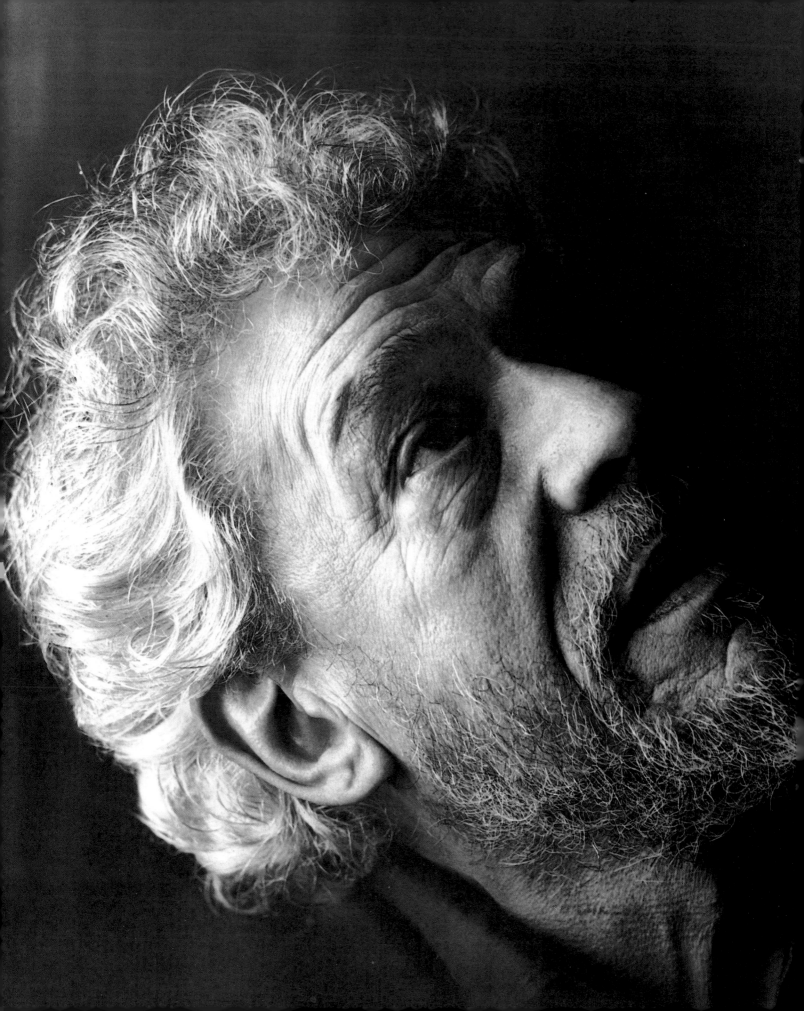

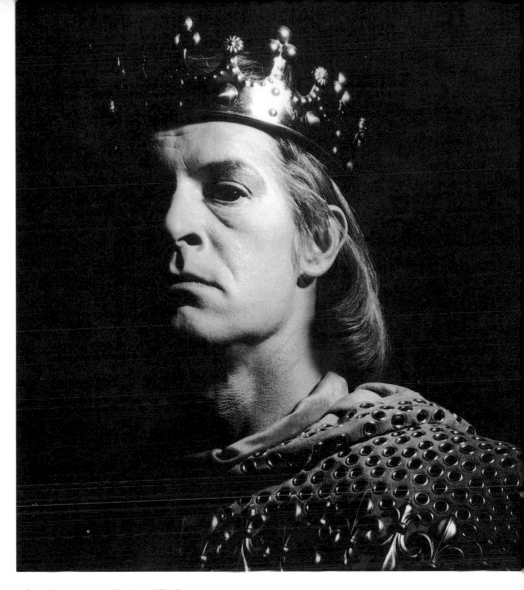

Alan Howard as Richard II for the
Royal Shakespeare Company in 1980.
He is the first actor to play the lead in
all Shakespeare's history plays

Paul Scofield; he played Oberon in
A Midsummer Night's Dream and
the Don in *Don Quixote*
at the National Theatre in 1982

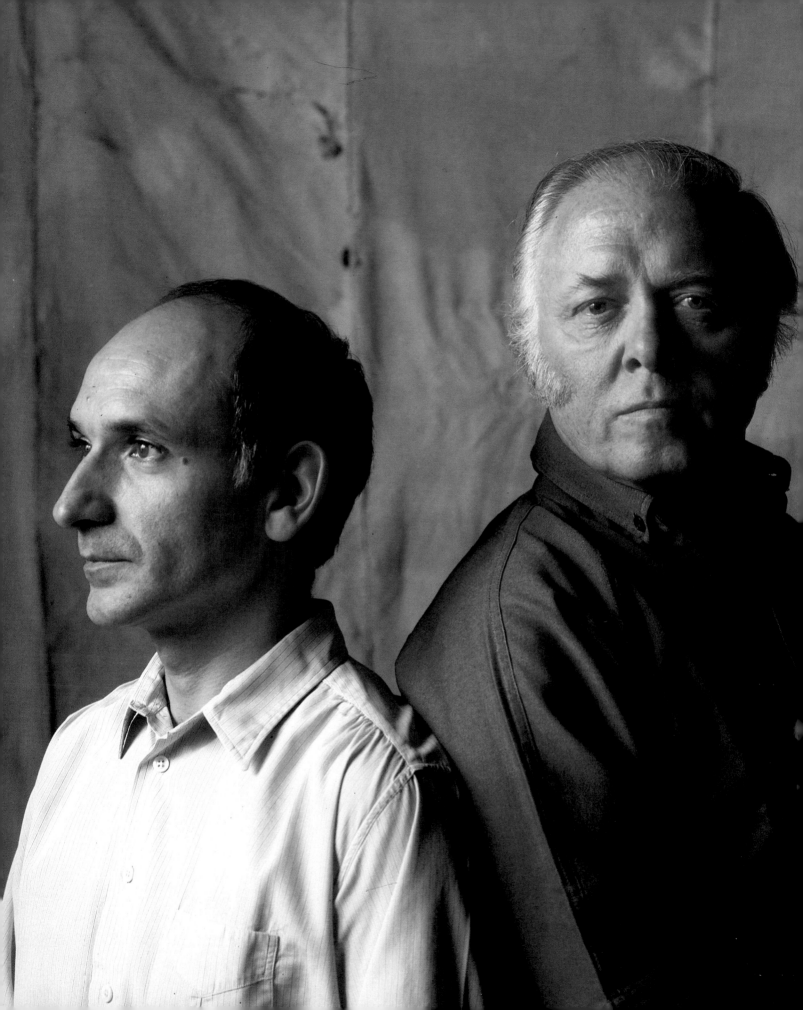

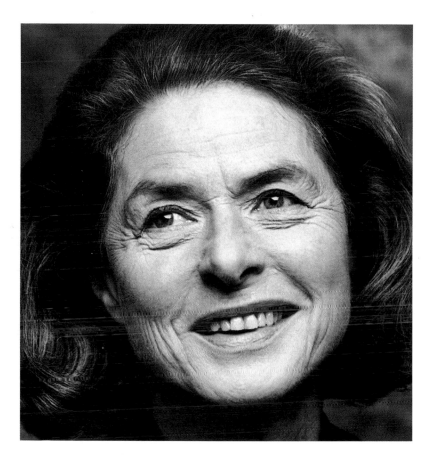

Ingrid Bergman; she made her last
film, *A Woman Called Golda*, in 1981

Sir Richard Attenborough, director of
Gandhi, with Ben Kingsley who
played the role. The film received five
British Academy awards and eight
Oscars, including Best Director, Best
Actor and Best Film, in 1983

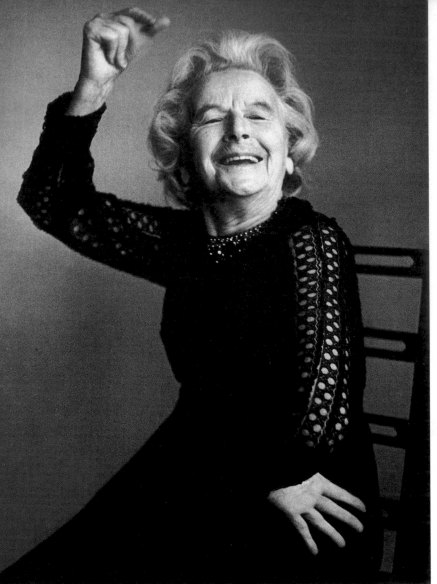

Dame Marie Rambert (*left*).
Sir Frederick Ashton (*below*),
and Dame Ninette de Valois (*opposite*),
pioneers of British ballet,
creators of the 'English style'

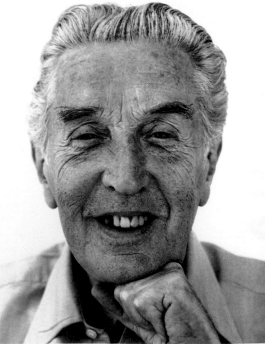

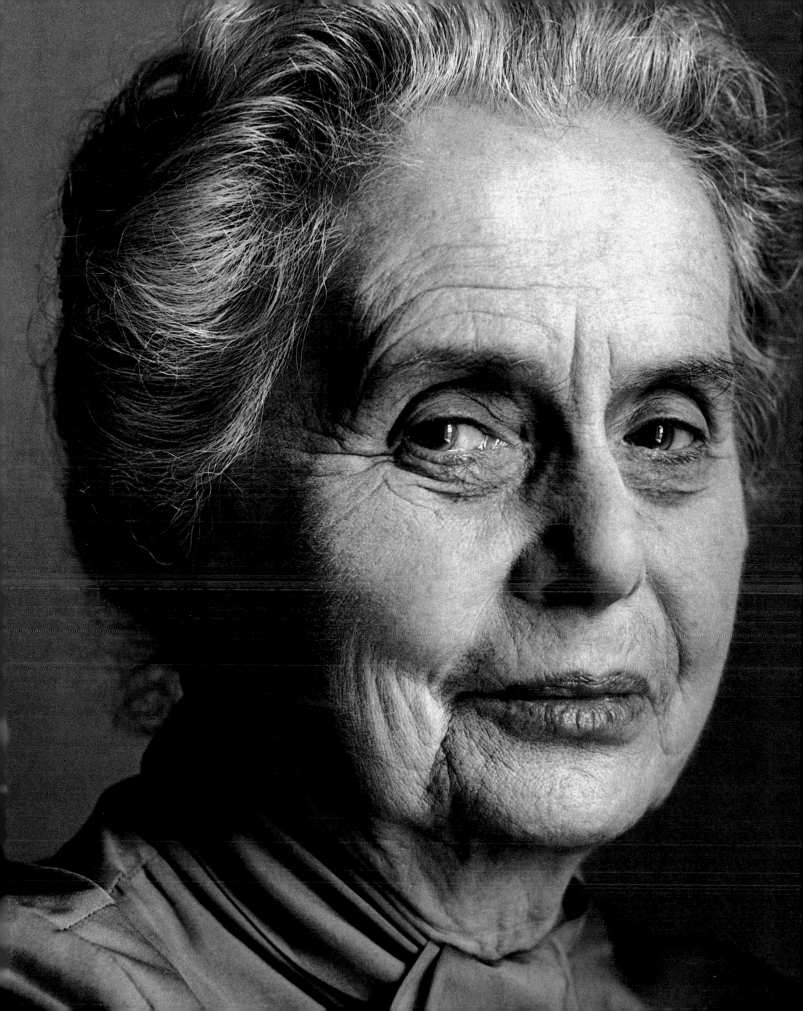

Harold Evans, ex-editor of *The Sunday Times* and of *The Times*, 1981

Rupert Murdoch, proprietor of *The Sun*, the *News of the World*, *The Times* and *The Sunday Times*, 1982

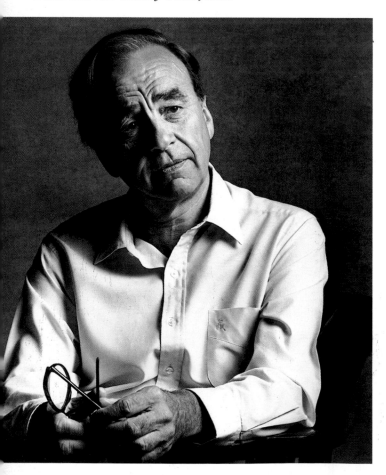

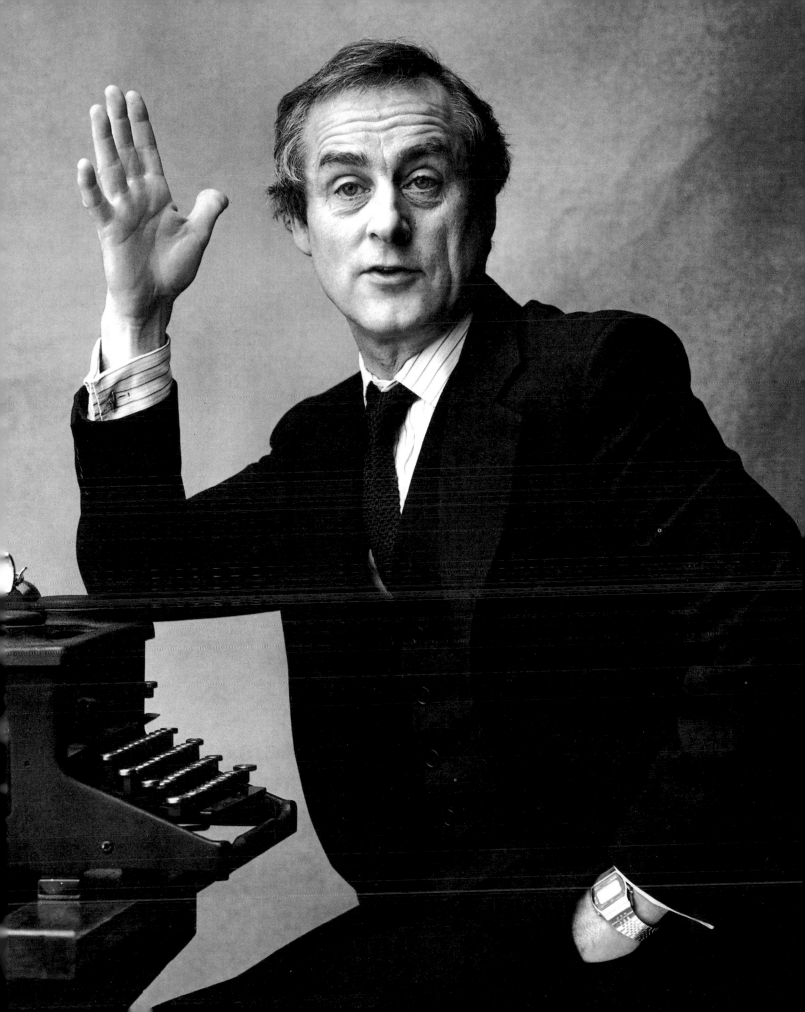

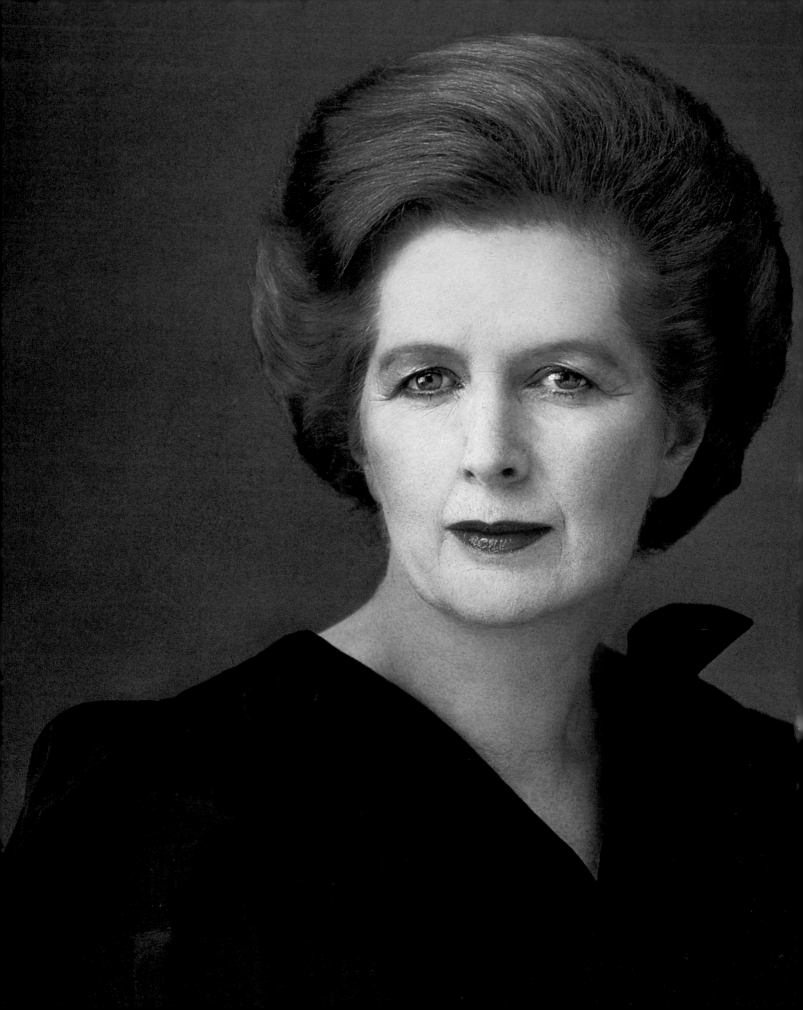

The Rt Hon. Mrs Margaret Thatcher, MP,
the Prime Minister, 1982

The Rt Hon. Mr Michael Foot, MP,
Leader of the Opposition, 1983

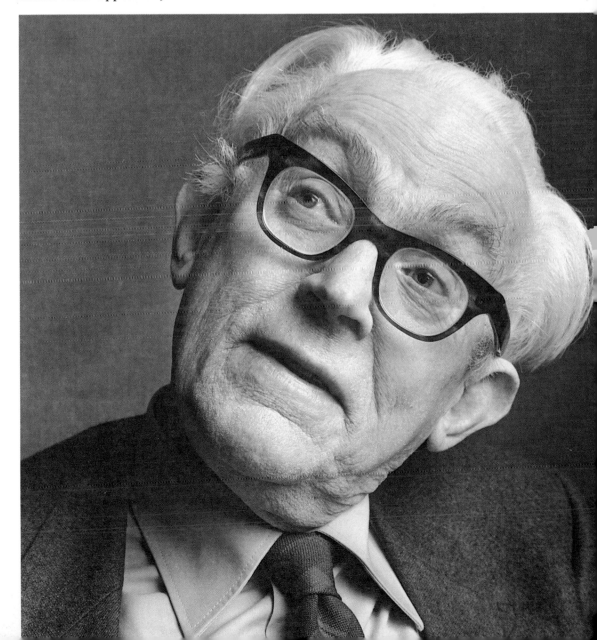

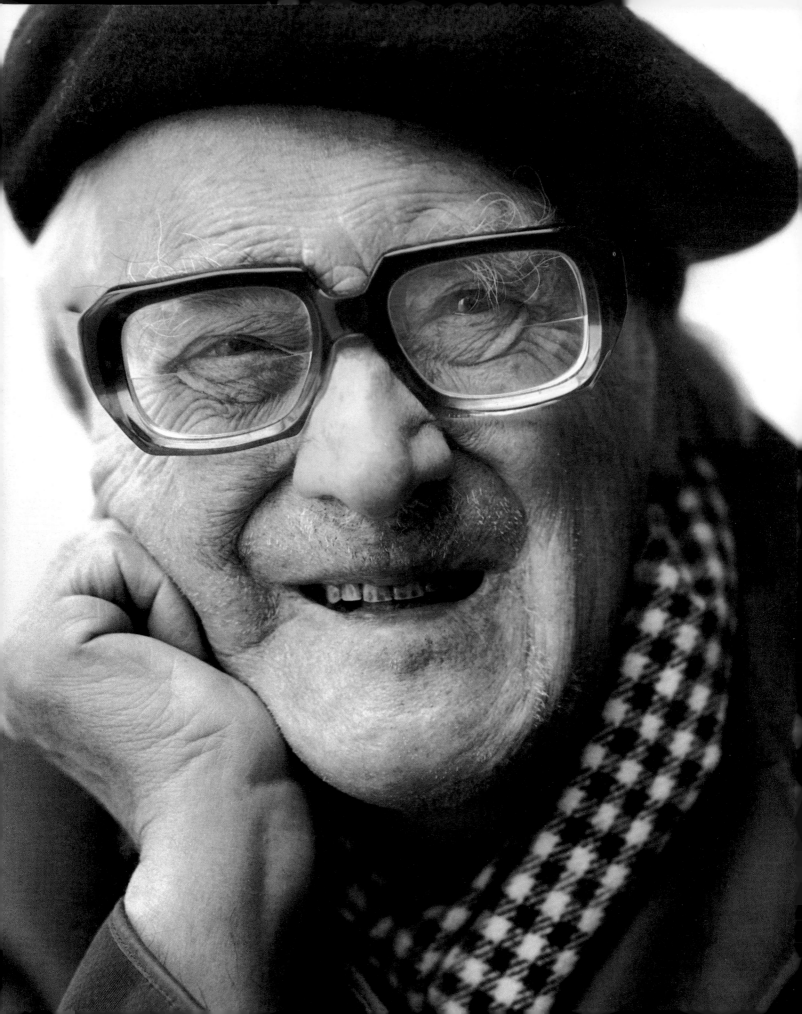

Lord Brockway aged 91, socialist, internationalist and pacifist; first elected an MP in 1929

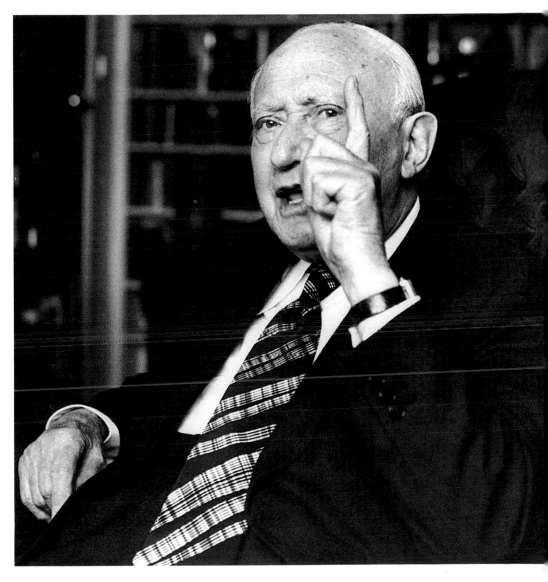

Lord Shinwell aged 95; on the Labour benches in both Houses of Parliament since 1922

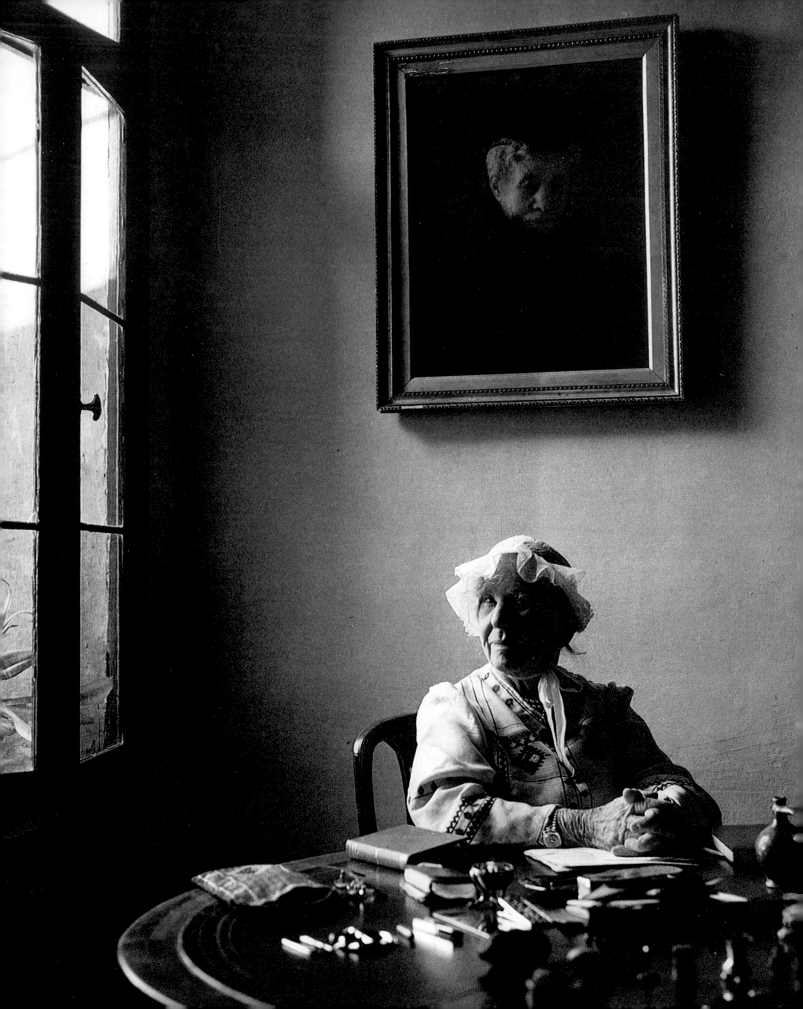

Dame Freya Stark, octogenarian
traveller, explorer and writer, before
setting off to the Himalayas in 1979

Lady Mosley (née Mitford), she has
lived in France for the last thirty years
where she became a friend and then
biographer of the Duchess of Windsor,
1980

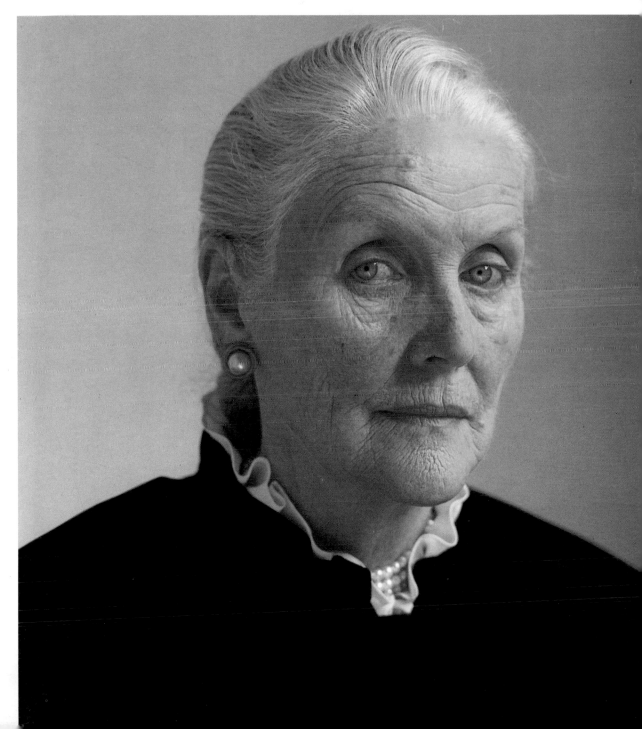

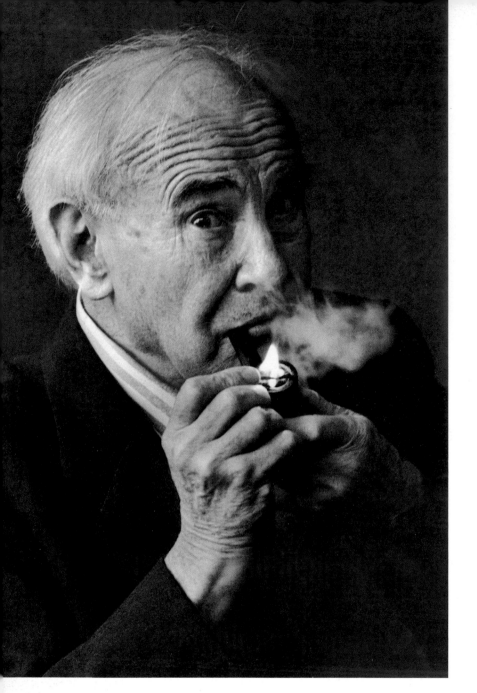

Malcolm Muggeridge, journalist,
broadcaster, author
and ex-editor of *Punch*, 1983

V.S. Pritchett, critic, essayist, novelist,
biographer; his *Collected Stories*
were published in 1982

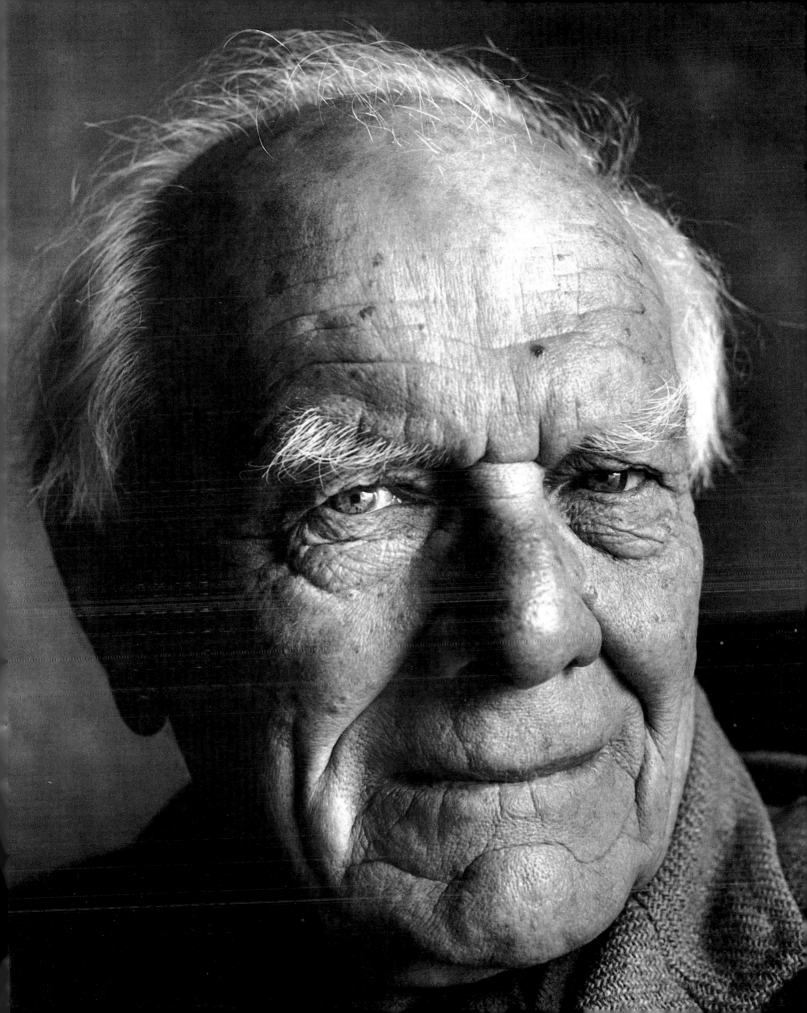

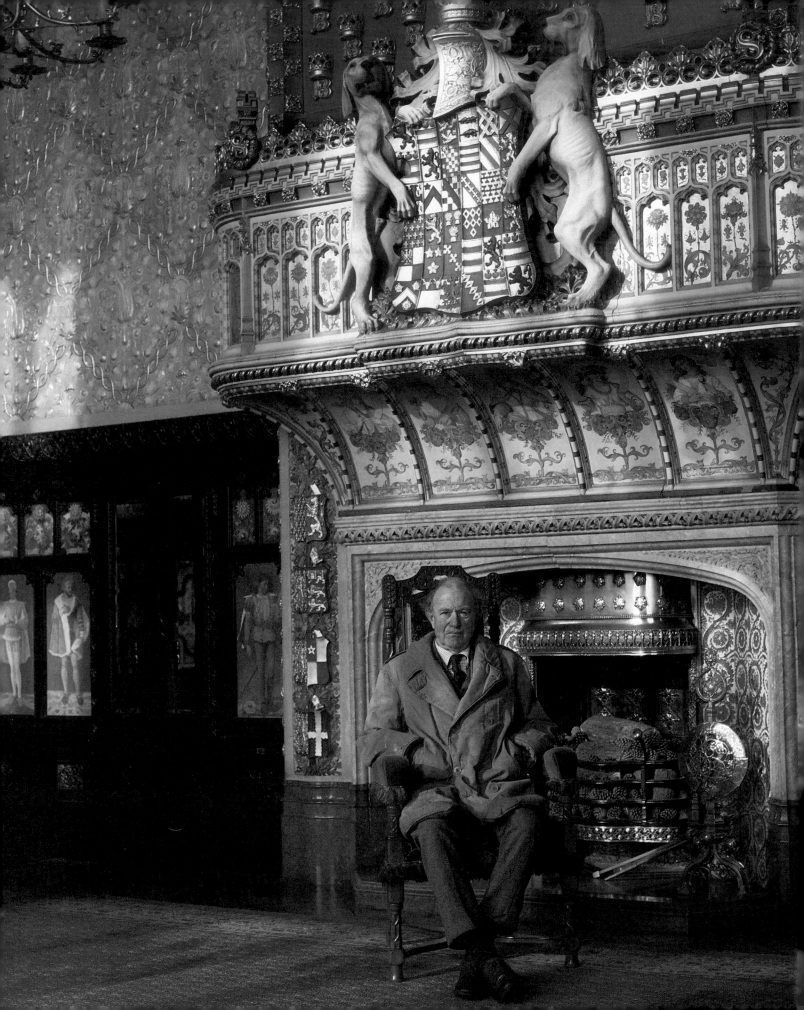

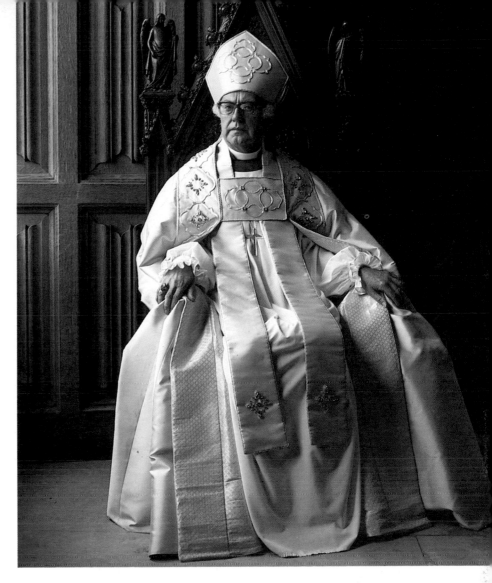

The Very Rev. Dr Robert Runcie,
the Archbishop of Canterbury,
in vestments he had designed
specially for the Royal Wedding in 1981

The Duke of Norfolk at his home
Carlton Towers in Yorkshire, 1982

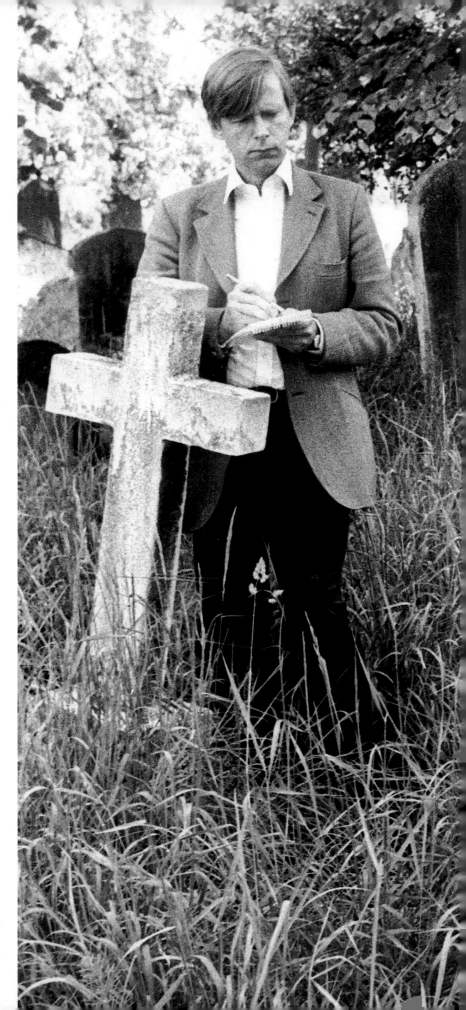

Lady Wilson, poet and wife of the
former Prime Minister, with her diary,
and John Wells who wrote
'Mrs Wilson's Diary' for *Private Eye*, 1980.
He wrote and played in
Anyone for Denis? in 1982

126

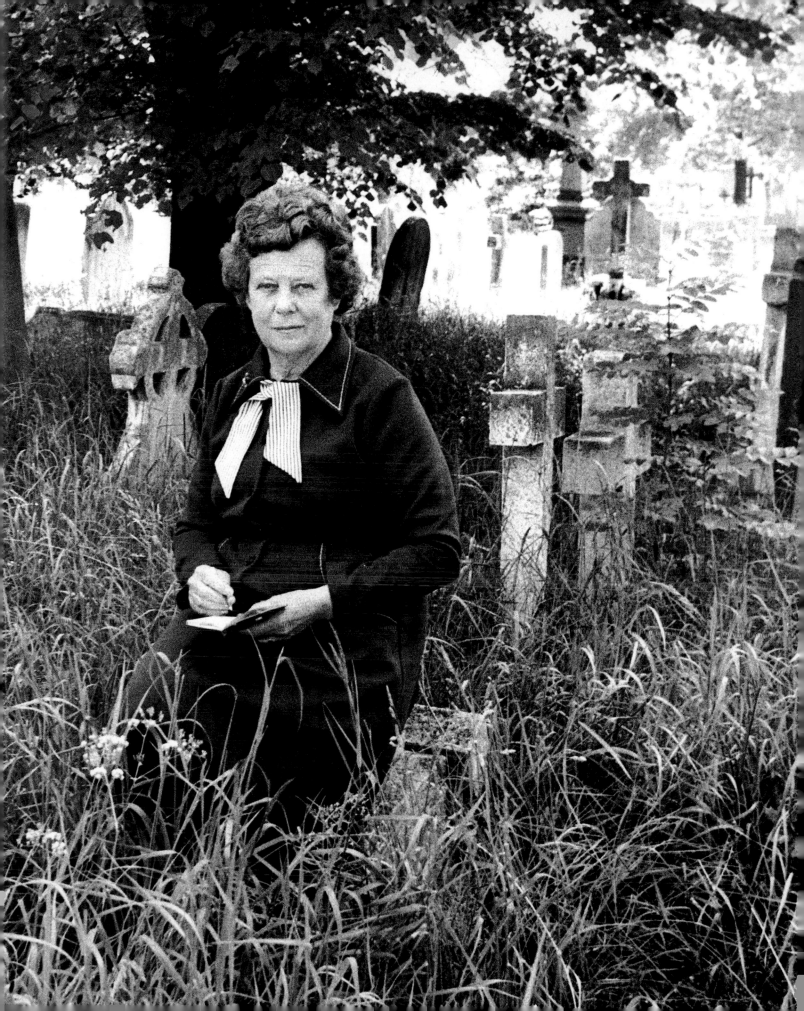

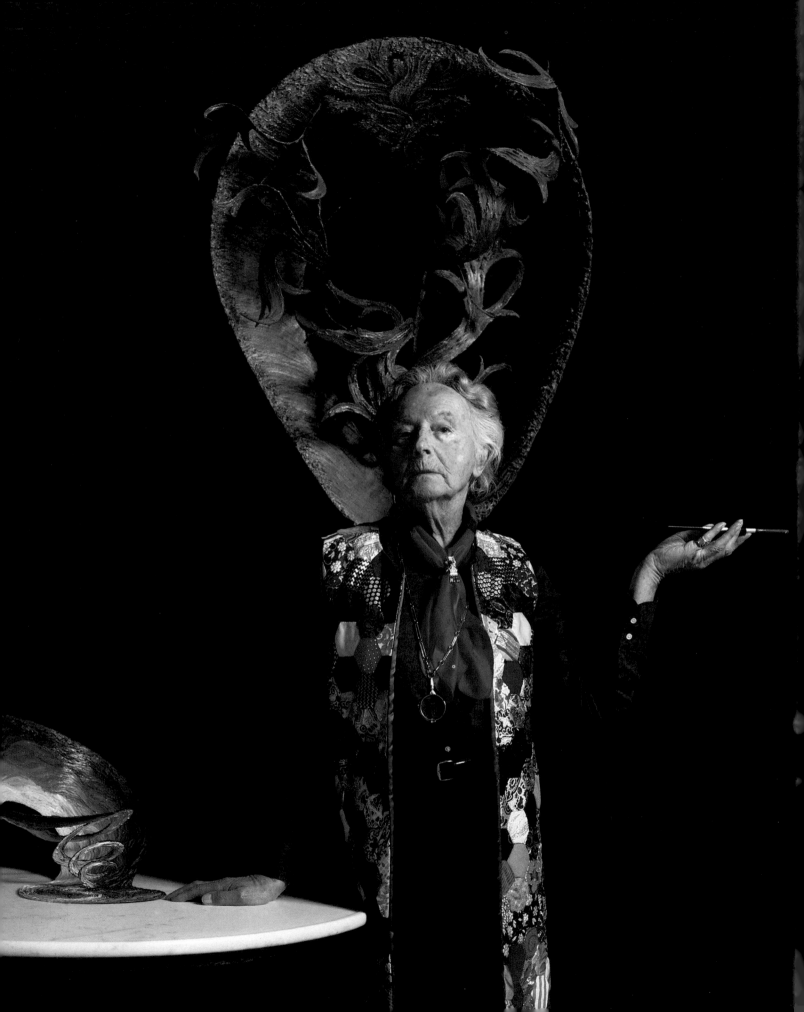

Erté aged 90; he has designed sets and
costumes since 1912. In 1980 he
designed *Der Rosenkavalier* for
Glyndebourne Festival Opera

Sir Sacheverell Sitwell, aesthete,
art historian, poet, writer;
An Indian Summer,
One Hundred Recent Poems
was published in 1982

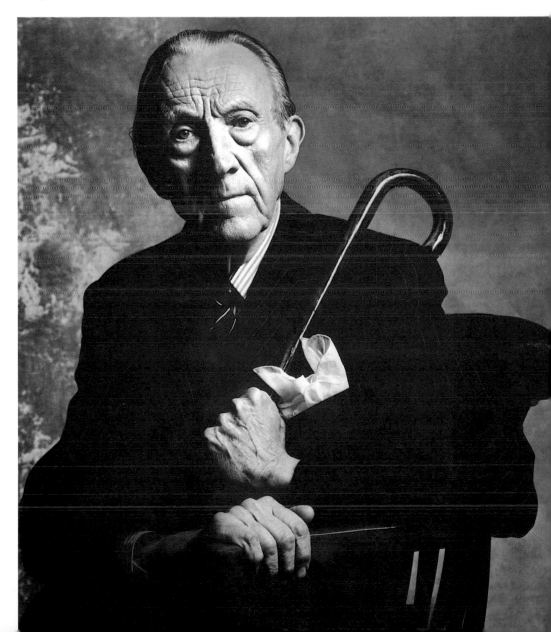

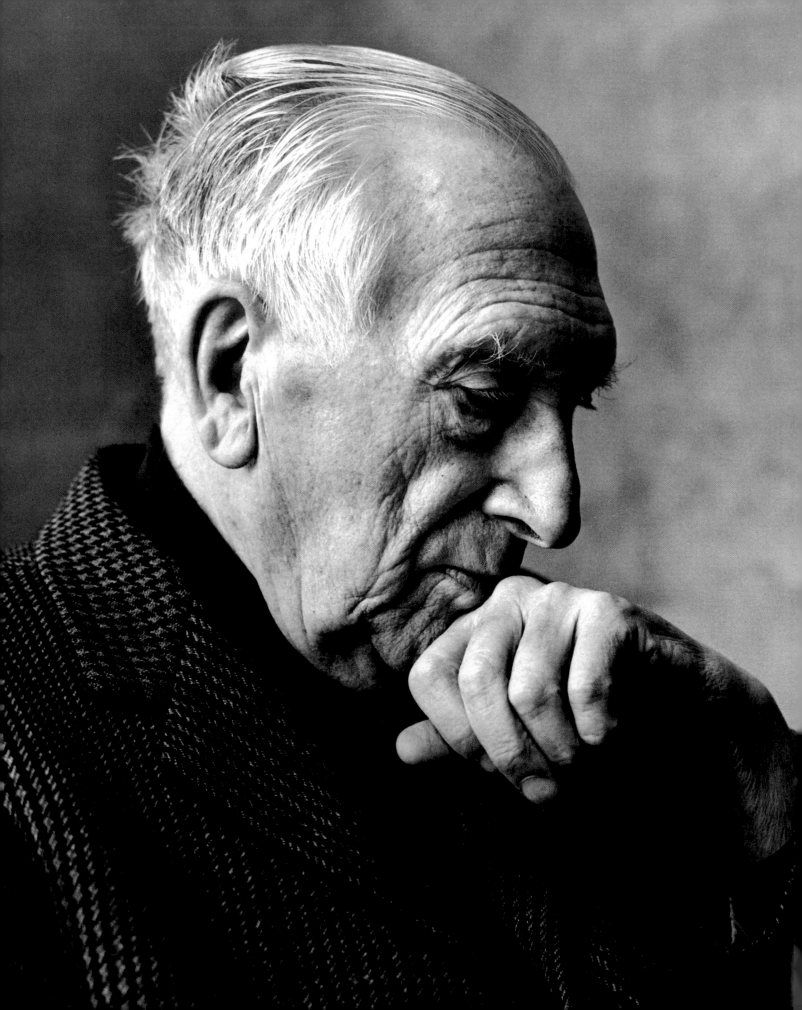

Sir William Walton, composer of *Façade*
and *Belshazzar's Feast*, 1980

Andrés Segovia aged 90, Spanish guitarist
in his hotel room in London, 1979

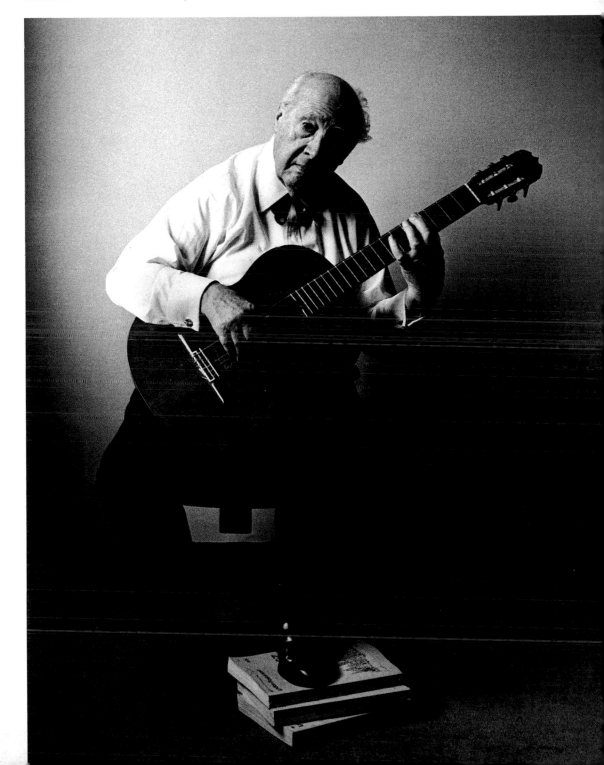

Dame Rebecca West, novelist and writer; her books,
The Young Rebecca: Writings 1911–1917,
and *1900*, were published in 1982

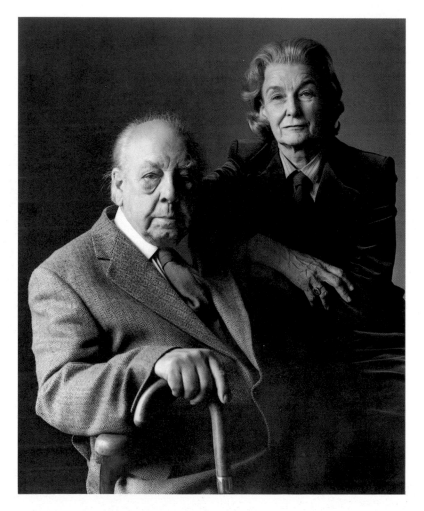

J. B. Priestley, dramatist, novelist,
biographer, with his wife Jaquetta Hawkes,
writer and archaeologist,
whose biography of Mortimer
Wheeler was published in 1982

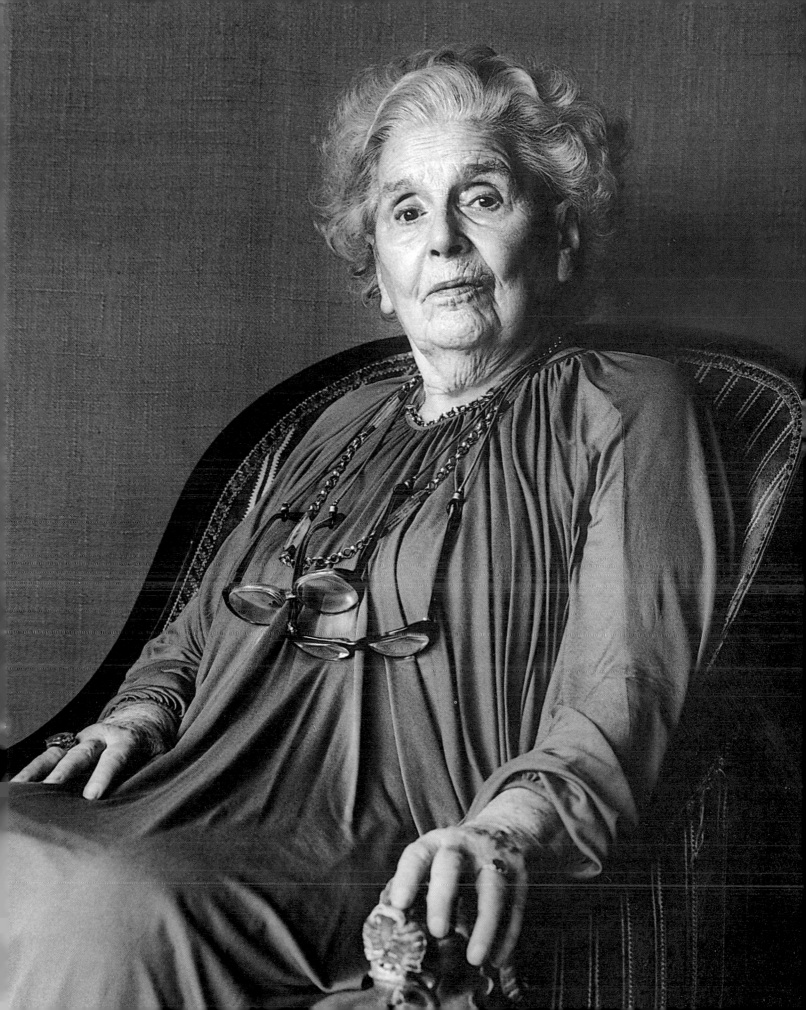

Vladimir Horowitz, Russian concert pianist
on his first visit to Britain
from the US for over 30 years,
at the Festival Hall in 1982

Angus McBean, innovator in
theatrical photography and
surreal photomontage;
his retrospective book was published
in 1982

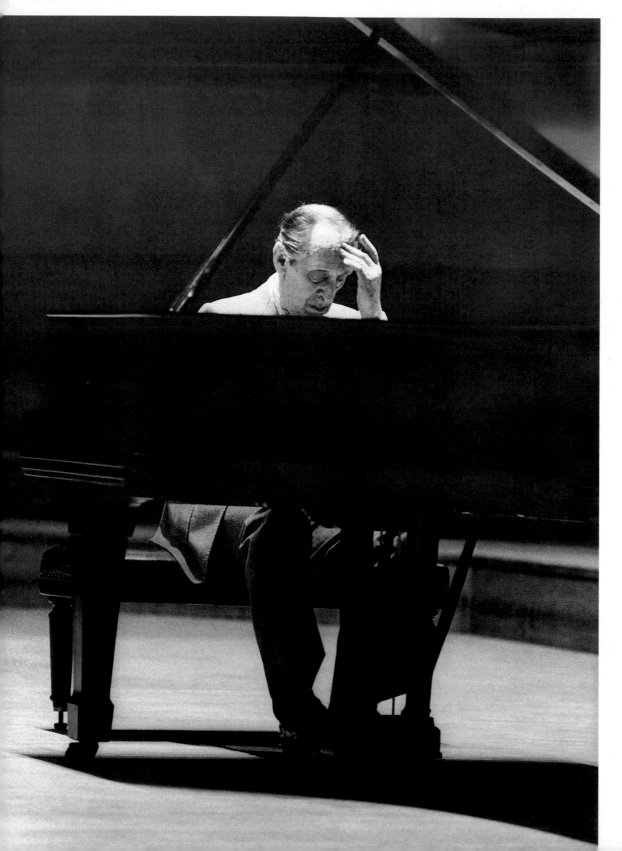

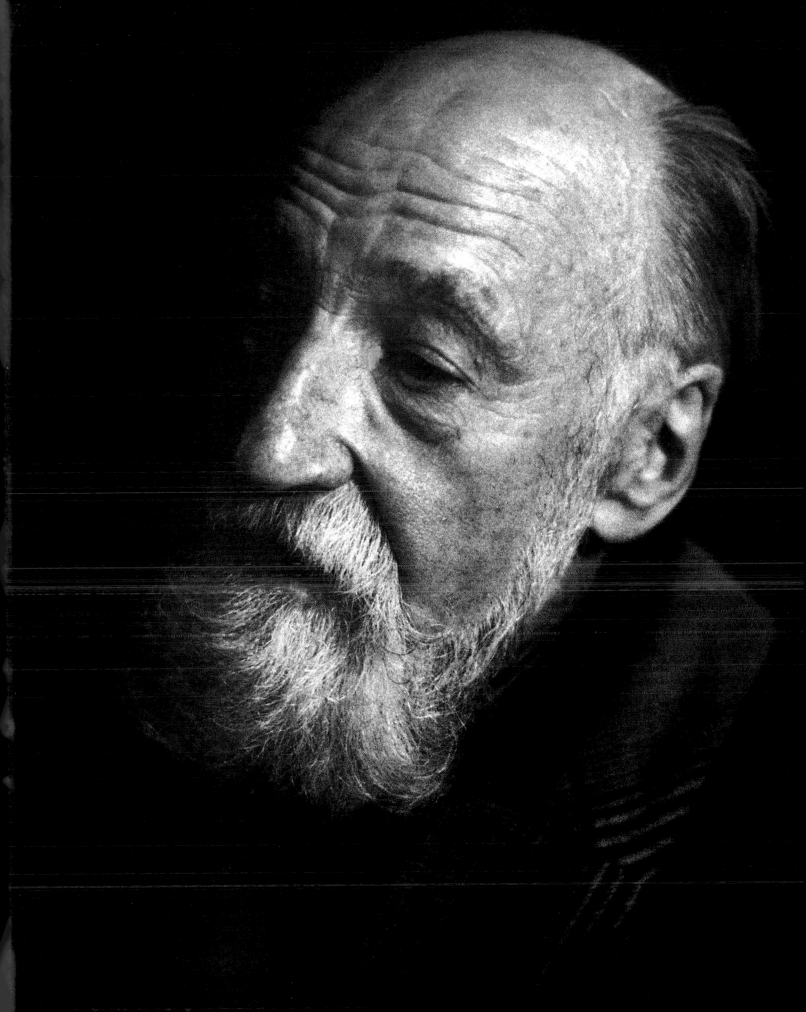

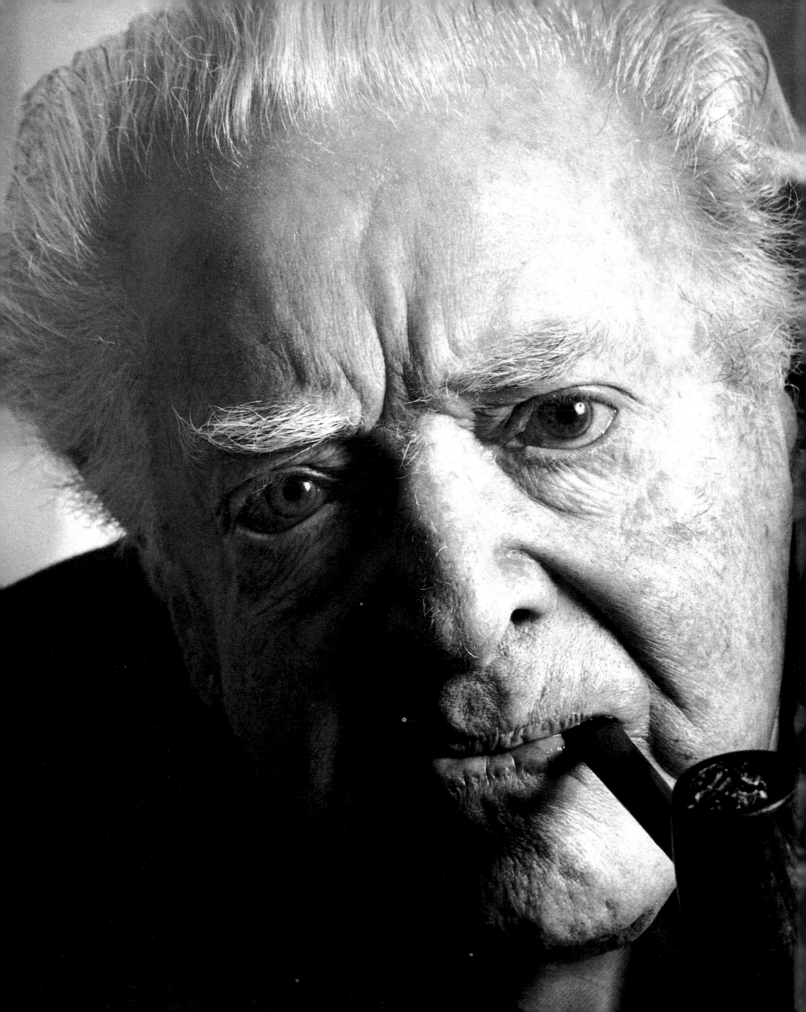

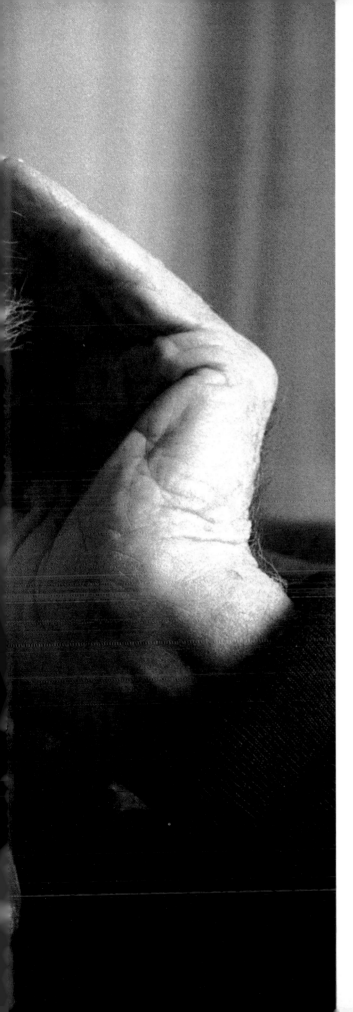

Ben Travers, playright; *Rookery Nook*,
first produced in 1926,
was revived in 1979

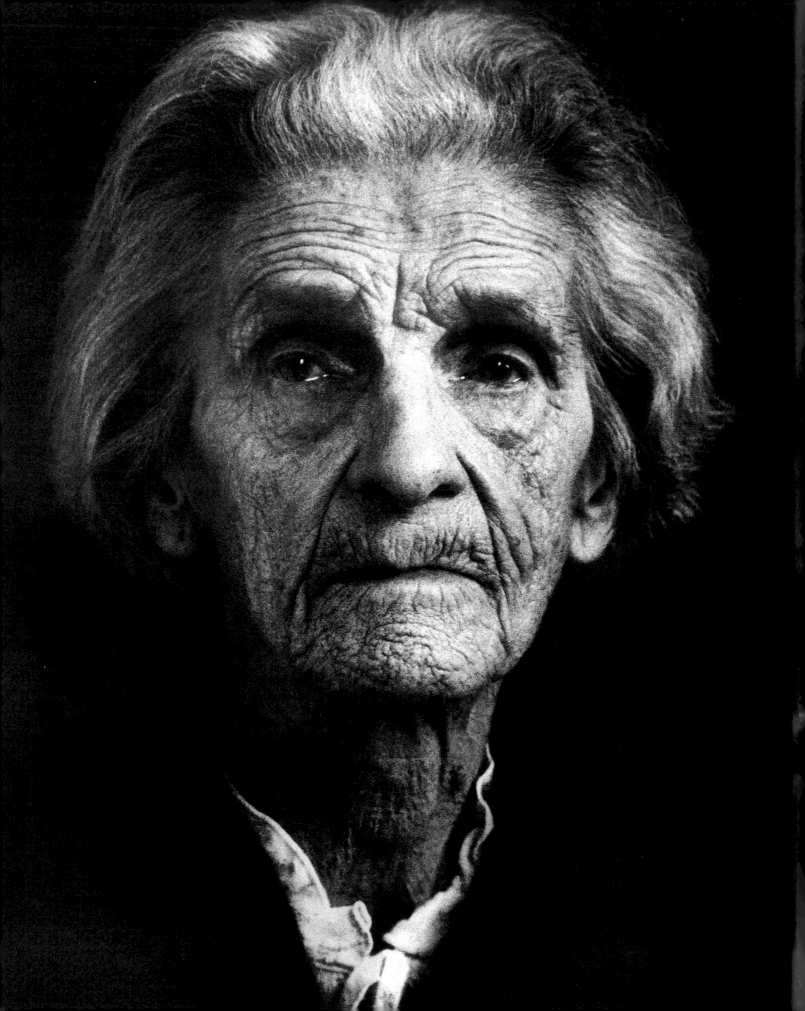

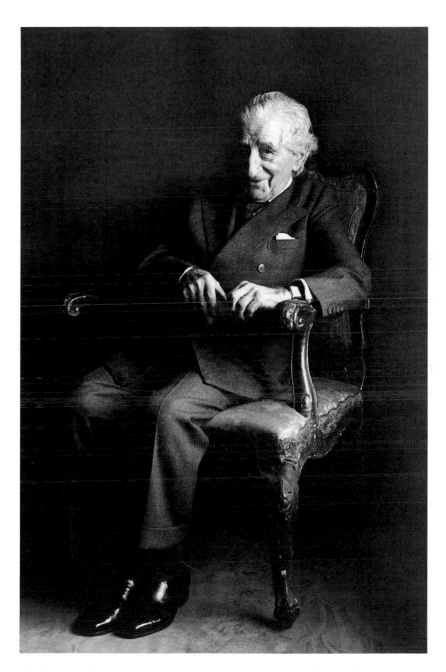

Sir Robert Mayer, patron and promoter of concerts for children,
aged 100, just before his wedding in 1980

Sir John Betjeman, Poet Laureate,
after a group sitting of authors, 1982

140

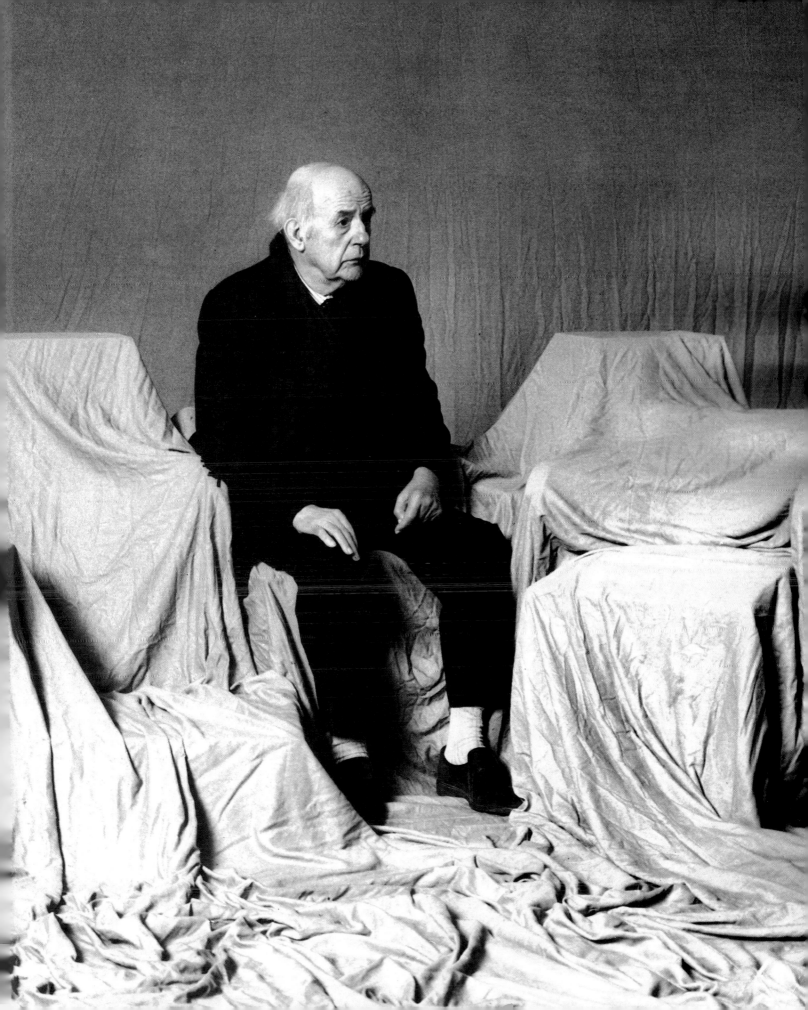

ACKNOWLEDGEMENTS

I would like to thank all the sitters in the book for their time and kindness in allowing me to photograph them; all those on *Vogue* who have been involved: Felicity Clark, Anna Harvey, Drusilla Beyfus, Alex Kroll and Lillie Davies and, in particular, the editor, Beatrix Miller, for her endless encouragement and Patrick Kinmonth who arranged and accompanied me at many of the sittings; Michael Rand, art director of the *Sunday Times*, who commissioned some of the assignments; Terry Lack for printing all the black and white photographs with such expertise, Terry Boxall for the finishing touches, Andrew Macpherson and Richard Dudley Smith for assisting me for the past three years and also my personal assistant, Kathy Baker, for the endless task of finding all the negatives and transparencies; Mark Boxer for his tremendous help with the text and Barney Wan for his inscrutable taste and tireless energy in choosing the pictures and designing the book.

SNOWDON

INDEX OF NAMES

Page references in *italic* type refer to photographs